ELEMENTS OF PAINTING SERIES

DRAMATIZE
Your PAINTINGS *With*
TONAL VALUE

CAROLE KATCHEN

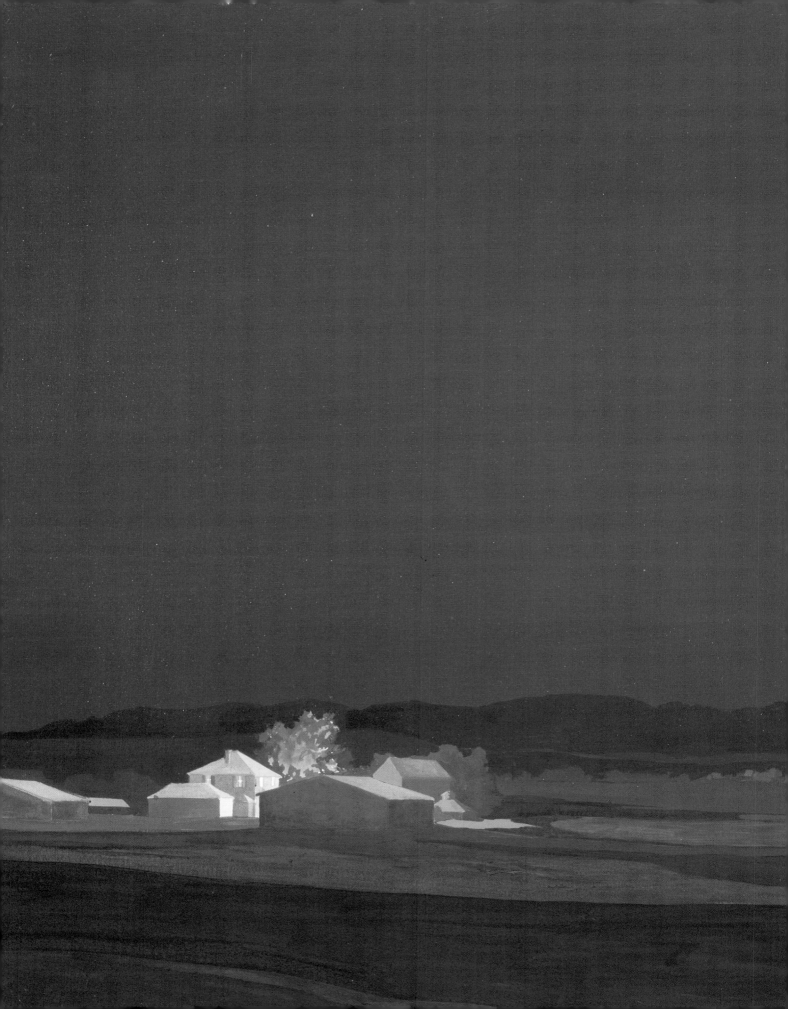

ELEMENTS OF PAINTING SERIES

DRAMATIZE
Your PAINTINGS *With*
TONAL
VALUE

CAROLE KATCHEN

NORTH
LIGHT
BOOKS

Cincinnati, Ohio

About the Author

Carole Katchen has been a professional writer and artist for twenty-five years. This is her twelfth published book. She has written articles for art and general interest magazines in the United States and abroad, including *Cosmopolitan, Parents* and *The Artist's Magazine*. Her paintings have been shown in galleries and museums in North and South America. Katchen currently lives in Los Angeles where she is director of public relations for Hurrah! Productions and writes and produces feature films. Her art is represented by Saks Galleries, Denver, and Hensley's Gallery of the Southwest, Taos.

97 96 95 94 93 5 4 3 2 1

Library of Congress Cataloging in Publication Data

Katchen, Carole
 Dramatize your paintings with tonal value / Carole Katchen.—1st ed.
 p. cm.—(Elements of painting)
 Includes index.
 ISBN 0-89134-477-2
 1. Shades and shadows. 2. Painting—Technique. I. Title II. Series.
ND1484.K38 1993
751.4—dc20 92-37709
 CIP

Edited by Rachel Wolf
Designed by Paul Neff
Pages 130-131 constitute an extension of this copyright page.

Dedication

This book is dedicated to Jerome Downs, Jane Downs, Candace Shivers, Matt Nadler, Greg Holch, Carol Eisenrauch, Bobby Minton and all my other friends and coaches at Landmark Education Network. Thank you for giving me an unlimited future.

Special thanks to the editors and designers of this book: Greg Albert, Rachel Wolf, Kathy Kipp, Sandy Grieshop and Paul Neff.
 And thanks to the wonderful artists whose work made this book possible.

Contents

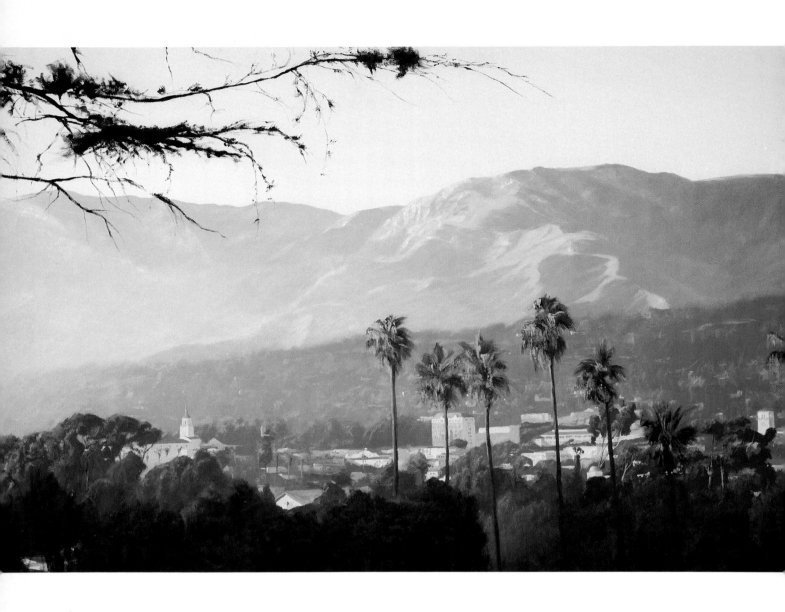

Introduction

Tonal value might be the most important component of any drawing or painting. What is tonal value? Defined simply, it is the lights and darks in a painting or drawing, and it is what makes almost all the other elements possible.

Without value contrast we cannot see line, form, texture, light or space. Imagine a white paper. Draw a black line on the paper. The line is very obvious. Now take a black sheet of paper and draw the same black line. The line is still there, but because the line and the background are the same value, we cannot distinguish the line.

Besides the visual impact, value also has a tremendous effect on the emotion or expression of a piece of art. The very words "light" and "dark" evoke an emotional response. A painting in which all the colors are light seems happy; a piece with all dark colors seems ominous or angry. Value *contrast* also creates mood. A painting where all the colors are of a similar value seems more peaceful than one with dramatic contrasts between light and dark.

Unfortunately, it's not always easy to learn to see tonal value. It tends to be obscured by color and texture. Even if an artist understands the principles of value, unless you can see value in the world and in your own work, you cannot use it to create more powerful images.

This book is designed, first of all, to help the reader *see* tonal value. Twenty excellent artists have contributed their paintings to demonstrate the principles and uses of value. Their value studies, step-by-step demonstrations and black-and-white photos of color paintings are also presented so that the reader can become more facile in distinguishing tonal value. Just by carefully looking at the illustrations, you will learn to recognize where the darks, lights and middle tones are and how they work together.

In addition, this book explores the principles of value so that the reader can begin to *understand* how those principles work: How does tonal value relate to color, light, form, depth, atmosphere, mood and composition? A full chapter is devoted to analyzing each of these elements.

Finally, *Dramatize Your Paintings With Tonal Value* provides a wonderful selection of exercises to help you learn to see and manipulate value. By completing these exercises you'll gain the *practice* that is an integral part of becoming a master of any painting form.

No matter what your skill level as an artist, from beginner to award-winning professional, a greater knowledge and control of tonal value will give your paintings more strength, solidity and impact.

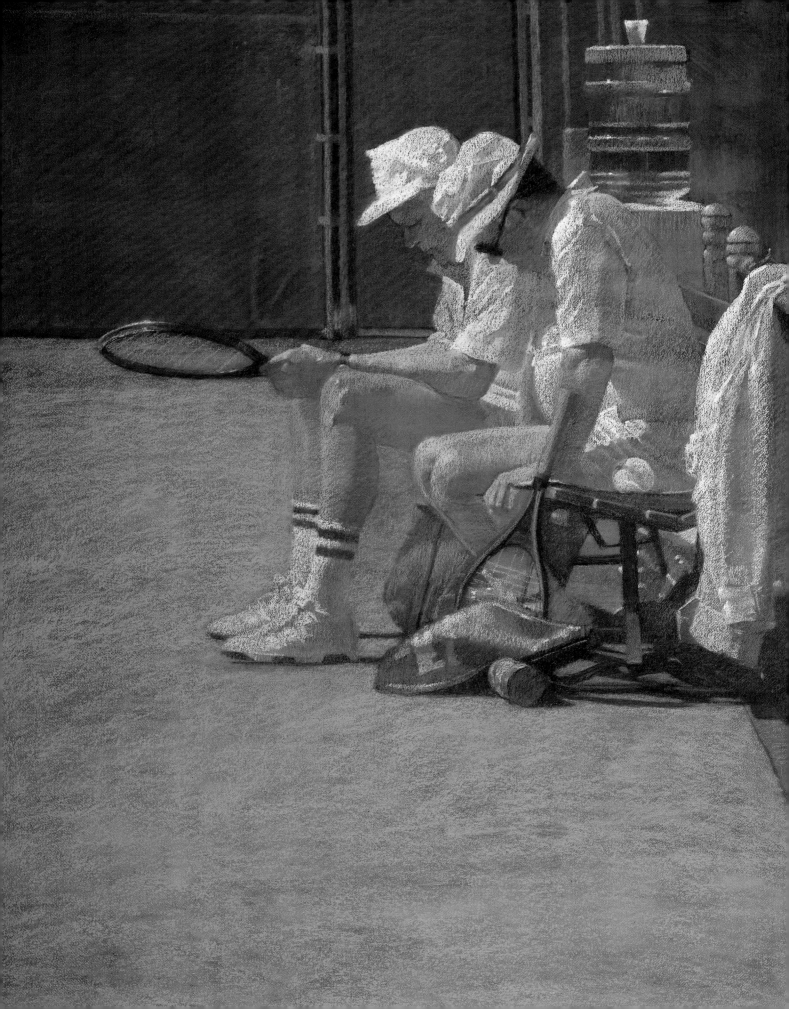

Chapter One
Seeing Tonal Value

Court Break
Sally Strand
Pastel, 56″ × 39″

Strand makes her paintings vivid by placing her subjects in strong sunlight and by carefully establishing the direction of the light. In realistic paintings it is imperative to maintain a consistent light source. Random light makes the painting look unreal.

When you first begin to paint, the main thing that you see (unless you are color blind) is color. You squeeze the colors onto your palette. Reds and greens and blues. Mix them. Dilute them. Stroke them onto your canvas next to each other, on top of each other. You are in love with the pure colors, sometimes more than the subject itself. They delight and exhilarate you as you fill the canvas bit by bit.

Then you are done with the painting and you stand back and . . . what happened! Where's the vitality? Where's the punch? The reds and blues and yellows are all there, but they look like . . . well, red and blue and yellow. None of the magic you felt when you were painting is apparent on the canvas.

You start again. This time you'll make the colors brighter. That should help. You finish and once again the picture is flat. What's missing?

What's missing is a structure, a foundation that will support the colors. What's missing is an organization of tonal values. Beginners are rarely able to see tonal value, the abstract shapes of light and dark in a subject or a work of art. Color gets in the way. Color is the most obvious component of a painting, but it is the placement of light and dark that gives your paintings power.

The Gray Scale

The simplest way to see values is on a gray scale. At right is a strip of toned boxes going from dark to light. The lowest box is the lightest—the pure white of the paper. Then each box gets progressively darker as more pigment is added until you reach the darkest box at the top.

A gray scale, or value scale, can be made with any medium—pencil, charcoal, ink or paint—and even with any color. The value scale shows you the range of lights and darks available with any medium and any pigment. If you want to know the range of values in a painting or drawing, hold a value scale against the painting and compare any area with the lights and darks on your scale. Thus you can see if you've pushed your medium to the broadest value range possible or if you've stayed somewhere in the middle. Sometimes you'll want a full value range, a painting with whites and blacks and all the shades in between. Sometimes you'll want to execute a painting with a more limited range, where all the colors are somewhere in the middle, neither light nor dark. As you proceed through this book, you will begin to understand the uses and advantages of each.

In traditional painting programs students are required to draw and paint only in black and white, often for years, so that they will learn to see values. Drawing over and over again in charcoal, the student is forced to disregard color and learns to see not only white and black, but all of the tones in between.

In this chapter are a number of wonderful paintings reproduced in both color and black and white. Look first at the color reproduction and identify the darks, the lights and the grays or middle tones. Then look at the black-and-white reproduction to check how accurate your eye was. Keep going back and forth until you are confident that you can see the dark, light and middle areas in the color reproductions.

Within a painting compare shapes that are next to each other. Which one is darker and which is lighter? It is easiest to see values in relation to each other.

Gray scale

A gray scale shows the gradual progression from very dark to very light. You can determine the value of any color simply by holding a gray scale against the color and seeing which box of the scale the color is closest to.

Notice as you look at the scale that the bottom of each box appears to be darker than the top. Squint your eyes to make it more obvious. That is an optical illusion caused by the relation between values. The same gray will look darker against a lighter gray and lighter against a darker gray. You can use this phenomenon to make your paintings more powerful. When you want a light section to look very bright, surround it by dark values, and vice versa.

Values in relationship

The value of a shape will appear different according to the values it is near. In both of these figures there is a black box and a lighter box. When the black is next to a medium gray, both of the boxes tend to look gray. When the black is next to white, the black looks very black and the white looks very white.

In your paintings you'll find that when you place similar values next to each other, they will blend. Contrasting values will intensify each other.

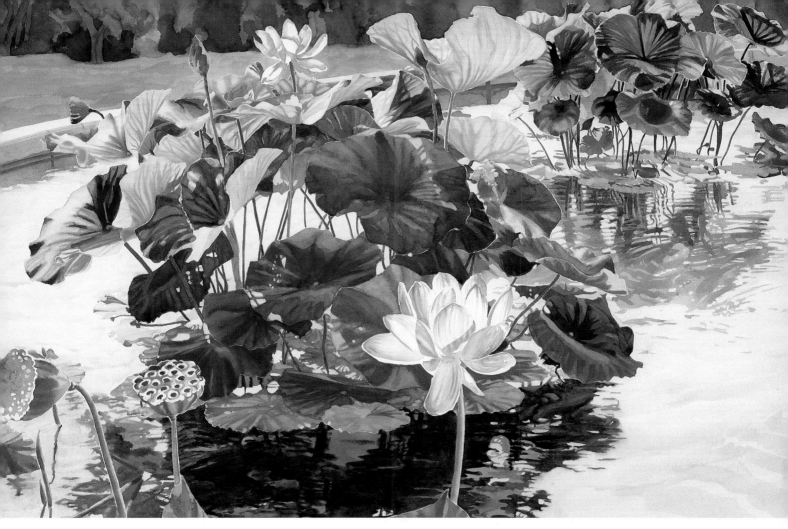

Looking for Patterns

The paintings presented here are of all styles. However, no matter what the style, medium or technique, there is always an underlying pattern of darks and lights.

Look at the painting above by Sandra Kaplan. As you study the color reproduction, you may see an arrangement of green, blue and pink. With all the detail in this piece, it may be difficult to identify the darks and lights. Look next at the black-and-white photo of the painting. It still looks like an intricate composition with no distinct pattern. But squint your eyes and look again at the photo. Now can you see the simplified pattern? This pattern can be rendered as a simple, two-value diagram of the composition (far right).

One of the best techniques to help you identify tonal values is squinting your eyes. When you allow only a small amount of light into the eye, you are better able to distinguish light, dark and middle tones. Individual strokes and de-

tails blend together. You are left with the larger forms of dark and light. Even a very complicated subject will be reduced to a more manageable arrangement of value shapes. Another technique is to look through a tinted piece of transparent plastic or glass—red works especially well. This will minimize the colors so that you can see values more easily.

Lotus Position
Sandra Kaplan
Watercolor, 40″ × 60″

In looking at this painting the natural way to divide it into shapes would be in terms of color—the pink, green, blue and white areas. However, what really defines the structure of the painting is the pattern of light, dark and medium values.

In the black-and-white photo you can see the light and dark areas more easily. And by squinting your eyes, you can discern an arrangement of large shapes of dark and light, reproduced in the diagram. It is this value pattern that gives the composition its power.

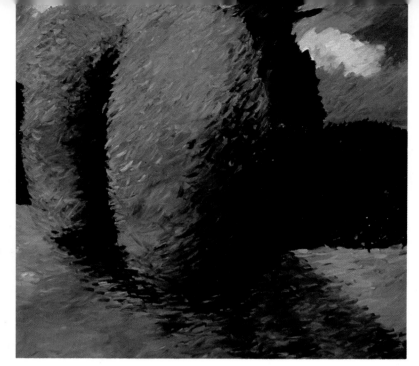

Stroke by Stroke

Every stroke that you apply to your painting has a tonal value. No matter what kind of pigment you use— watercolor, oil or pastel— the stroke is light, dark or middle value. A painting that illustrates this concept very clearly is *Garden With Hedge* (at right) by Eleanore Berman. In the black-and-white photo you can distinguish the value of every single stroke.

But pigment is not the only source of tonal value. The surface on which you paint, the paper or canvas, also has a value. Watercolorists who leave untouched white paper for the lightest areas of their picture are especially aware of this. Many oil or acrylic painters paint a single color onto their canvas before they begin to paint the image, and many pastellists work on colored paper so they will be applying color to a middle value rather than white.

By organizing the strokes and the surface tone according to light, dark and gray you create a value structure for your painting. This is what is called the value composition. Learning to plan and control the value composition will give your paintings harmony, movement, balance and dramatic impact. (See chapter seven for more on composition.)

Value Relationships

As you arrange your values, you will quickly find that lights and darks exist in relation to each other. Take a medium gray stroke. Place it in a painting that is mostly light and the stroke will appear quite dark. Put the same gray stroke in a very dark painting and now it looks light. Put a medium gray next to a black and they both appear gray. Put a white next to a black; the white looks very white and the black looks very black. Study the paintings in this chapter and notice the relationships of values. Where are similar values placed next to each other? Where

are contrasting values juxtaposed?

Look at the two landscapes at right: *Abiquiu, NM*, by Susan Shatter, and *Waynesville Daybreak*, by Robert Frank. They are excellent examples of different relations of values and the results that can be produced by greater or lesser value contrast.

In *Abiquiu, NM*, Shatter has used the total range of values, from very light to very dark, and she has placed them against each other throughout the painting. The result is a painting of tremendous drama and movement. This is more obvious in the black-and-white photo where the eye is not distracted by the rich color.

Robert Frank's gentle, Midwestern landscape is a contrast to Shatter's painting. Here there are a few light lights and dark darks, but the majority of the painting is done in various middle values. The result of this treatment is a soft, tranquil scene with no strong contrasts to jar the viewer.

One of the most interesting

Garden With Hedge
Eleanore Berman
Oil, 74" × 76"

In this painting you can see how the individual strokes of color blend visually to create three-dimensional forms. In the black-and-white photo you can see that each stroke not only has color, but also value. Notice how strokes of similar values blend together and strokes of great contrast remain distinct.

techniques used to present value is texture. The separate strokes of a textured area may be of several different values that blend visually to create the impression of one shape. In *Northern Exposure*, by Mark Mehaffey (see page 8), the shapes are composed of many specks of pigment. What you "see" as a medium or dark shape is actually the combination of many darker and lighter pigments that appear separate up close, but fuse as you look at them from a distance.

Many pastellists choose to work on toned paper rather than white paper. This gives them more control of their middle values. Much of the beauty of pastels comes from the delicacy of the light tones. However, these tones only look light against darker values. Even pinks and yellows can look dark against a white background. For a similar reason, painting against a black background is very difficult because all but the darkest tones look bright against the black surface.

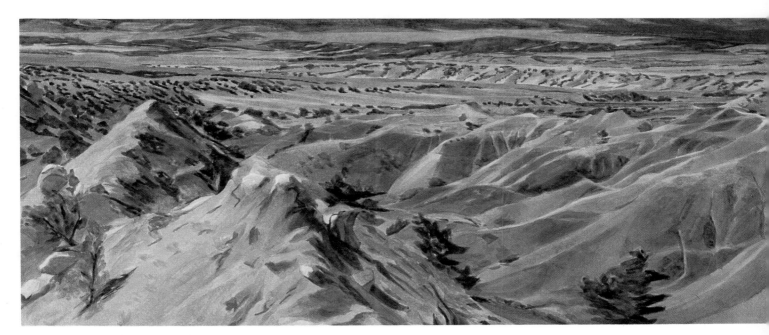

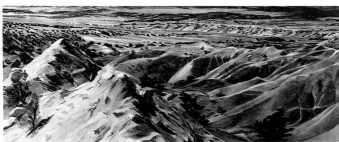

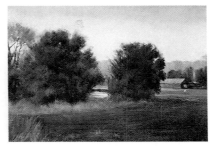

Abiquiu, NM
Susan Shatter
Watercolor, 26" × 60"

Waynesville Daybreak
Robert Frank
Pastel, 19" × 25"

These two paintings are very different in style, media, color and also tonal value. Shatter's painting bounces very light and very dark areas off of each other. The result of this contrast is a dramatic painting with great movement. In contrast, Frank's painting is done almost entirely in the middle range of values. Having less contrast, this is a quiet, gentle piece.

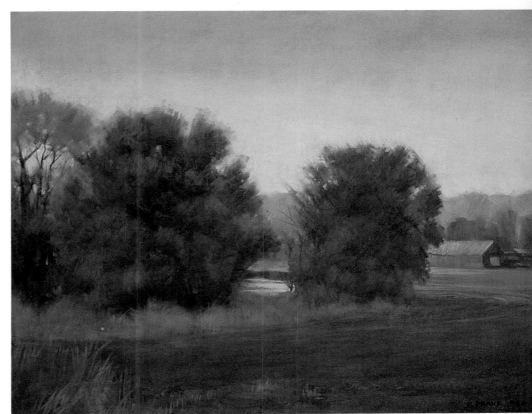

Choosing Your Way

As you can see from the previous examples, there is no "right way" to use or organize value. It varies from artist to artist and from painting to painting. Even with similar subjects the possibilities are endless. Look at the figures on the next page, painted by Everett Raymond Kinstler and Deborah Deichler. Both figures look very solid; both paintings have a strong sense of light and a definite mood. However, Kinstler's painting is done almost entirely in middle values whereas Deichler's is divided between strong darks and lights.

Paintings can also be equally effective done completely in high (light) or low (dark) key. *Midnight Gardener*, by Barbara Kastner, is a dark painting with a few light areas. William Wright's *Baskets With Moran* is a light painting with dark accents. Both still lifes are powerful images. What is important to note here is that the artist makes the choice. *You* decide. Will it be a dark or light painting? Will it have great or little contrast? Your choices about value create the foundation for your painting and in many cases determine the success of the finished piece.

However, before you make any of these choices, you have to be able to *see* value. Look at paintings and look at subjects around you in terms of light and dark. Squint your eyes; look through a piece of red plastic. Compare one shape to another—which one is lighter and which one is darker? The better you are able to distinguish tonal value, the more powerful your paintings will be.

Northern Exposure
Mark Mehaffey
Watercolor, 22" × 30"

Mehaffey paints in a pointillistic style, building up shapes with dots of color. In the sky area the colors range from magenta to green. However, because the colors are all of similar value in that section, the dots blend to look like one solid shape. He uses dots to create both the light and the dark areas. Notice the dramatic effect caused by placing very light areas next to very dark areas, such as in the pointed roof.

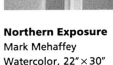

Exercise
Seeing Value

Arrange a setup of all white objects on a flat, white surface. It might be eggs and teacups on a white tabletop or any other arrangement that you choose, but it must be all white. Now shine a spotlight on the setup so that you can see definite highlights and shadows.

With charcoal or any other single color of chalk or paint, complete a picture of the still life showing where the highlights and shadows fall. In looking for the highlights and shadows, you will begin to see tonal value.

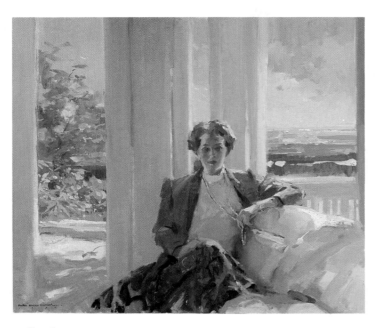 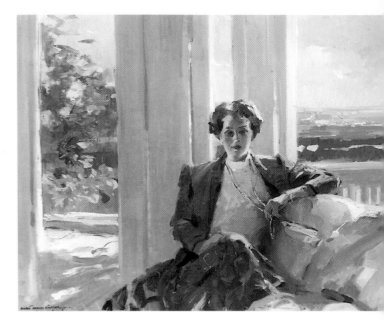

Reflections
Everett Raymond Kinstler
Oil, 40″ × 46″

Katy K.
Deborah Deichler
Oil, 8⅜″ × 6¾″

Any subject can be handled with either a full or a narrow range of values. In her portrait, Deichler has gone from white to black. Kinstler, on the other hand, has worked more in a middle range, using only a few very dark and light accents. Deichler's darker painting creates a "darker" mood; even though the subject is a little girl, we sense a depth and seriousness in her thoughts. The lighter painting has a more easygoing feel to it.

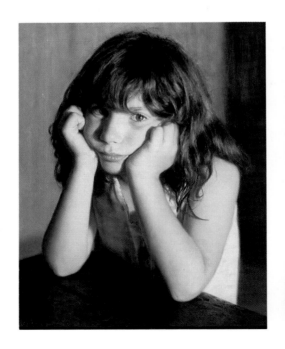 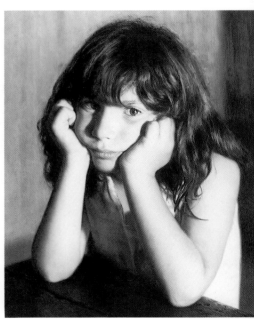

Midnight Gardener
Barbara Kastner
Acrylic, 36″ × 48″

Baskets With Moran
William Wright
Watercolor, 28″ × 21″

These two still lifes show that an effective composition can be created with mostly dark shapes and a little bit of light value or mostly light shapes with small, dark accents. In both cases the extreme contrast adds visual drama to the piece; however, the mood is very different. The darker piece looks mysterious, while the lighter one looks open and friendly.

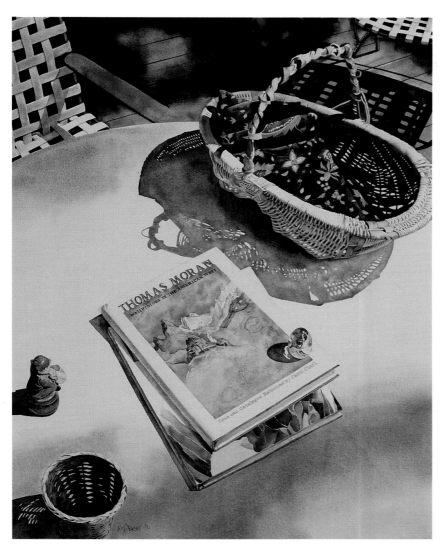

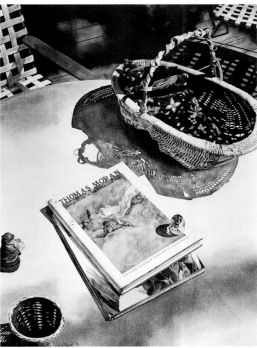

Exercise

Dark, Medium and Light

Select a painting subject—still life, landscape or figure. Look at it carefully. Identify the dark, gray and light areas. Study the subject until you feel that you can distinguish the three values.

Now take a sheet of white paper at least 11" × 14" and in black or very dark gray, draw only the dark areas of the subject. Do not differentiate between areas that look black and very dark; make them all the same dark color. If you have trouble seeing which are the dark areas, squint your eyes.

Next take a piece of tracing paper the same size as the first drawing and draw only the middle values. Use one gray tone to draw all of the middle values; do not distinguish between the medium tones.

Now place the second drawing on top of the first. The lights appear where you have not drawn a medium or dark value. When you are finished, you will have a map of all the dark, middle and light values in the subject.

Seeing Value First

Collectors love Sally Strand's paintings because of the beautiful pastel colors, but to Strand color is secondary. "Value is the key," she says. "If the values are wrong, you are going to have dull color."

Strand begins each painting by first analyzing the values. She starts with thumbnail sketches. In these studies, which are 2″ × 3″ or 3″ × 4″, she breaks the subject down into an abstract pattern of three or four values. She finds the large shapes in the scene and puts them down in pencil as dark or middle gray areas, leaving white paper for the light areas.

Strand looks at the composition almost as two separate paintings— the dark side and the light side. She develops the shadow side first, the dark to middle tones, which she considers the structure or skeleton of the composition. She starts by "keying" the darks, establishing the darkest dark and the lightest dark first. Then all the other darks are developed in relation to that first value, going from dark to middle value.

She tries not to get to the lights too fast. It is having the darks and middle tones in relation that makes the lights "pop." As she lays in her light colors, Strand is careful that the darkest light is lighter than the lightest dark. In other words, the dark side must be consistently darker and the light side must be consistently lighter than the other side.

"You have to see it in the biggest shapes, not just the shadows on the figure, but the whole figure on a light background," says Strand. "You have to hold to your basic pattern in order for the painting to have guts."

She doesn't worry about exact color, as long as the values are right. To test that, she squints at the painting or walks across the room and looks at the painting from a distance. Once the values are set, it is easy to adjust the pastel colors, mixing one color into another to gray them down, increase the intensity or change the temperature.

Viewers often comment on the sparkling whites in Strand's sunlit paintings. They are rarely white at all, but a variety of colors in very light values. A bright area of a "white" shirt can be lavender and pink and green and blue. It is not the color that she is trying to show, but where the bright light is falling.

"Using the whole range of tonal values makes the whites sparkle," says Strand. "I look for the lightest lights and surround them with darks. For a long time I thought I was painting people. Now I see that I am painting beautiful light patterns."

Pencil roughs

Strand begins each painting by working out the organization of values in tiny black-and-white studies, no larger than 3″ × 4″. In these drawings she divides the image into large shapes of dark, medium and light value and establishes the direction of light and shadows.

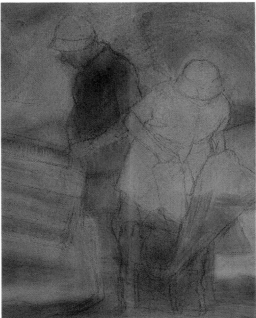

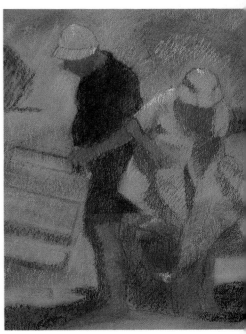

The Best Spot
Sally Strand
Pastel, 20" × 14½"

Step 1

Working with charcoal on heavy water-color paper, she loosely renders the outlines of her subject.

Step 2

She loosely washes in an underpainting in watercolor to establish value and color temperatures. She refers to the small pencil roughs for placing the areas of dark and light.

Step 3

With pastel she develops local color and value. She applies the pigment in quick, loose strokes, building up solid-looking areas by overlaying many colors of similar value.

Step 4

In this piece the artist convinces us of the strong sunlight by contrasting bright highlights and deep shadows. For her whites she actually combines many very light colors. There is very little detail in this painting. Instead, it is made solid looking by the effective use of values.

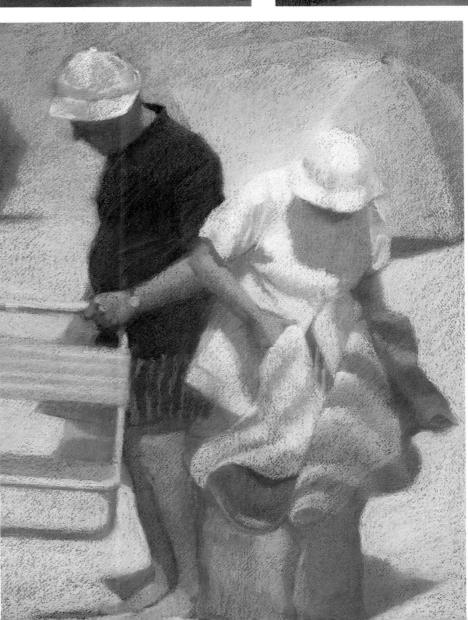

Day Off
Sally Strand
Pastel, 23½" × 42"

Strand often divides a painting into a light side and a dark side to correlate with the sun and shadow. Here she simplifies the figure almost as a silhouette. The figure is the dark area and the background and cooler are the light areas.

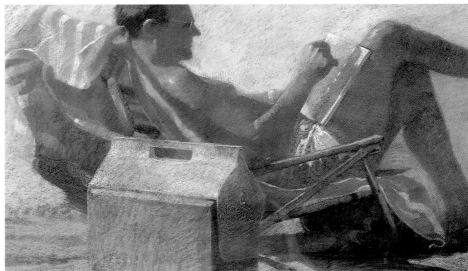

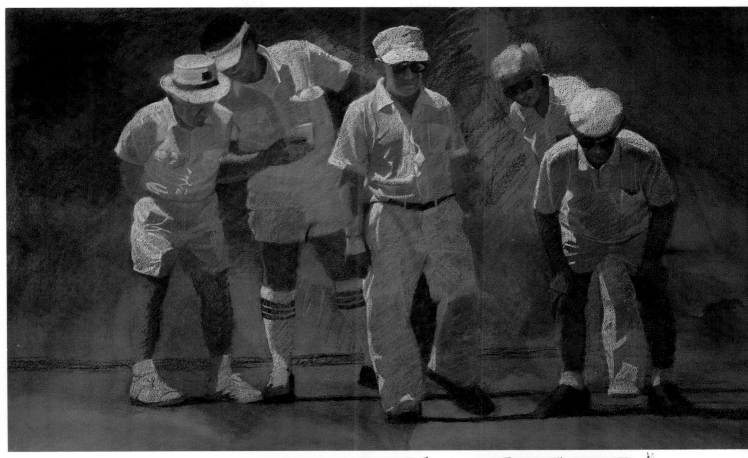

Men in White
Sally Strand
Pastel, 36" × 56¼"

Strand develops the value composition in little drawings in one of her many sketchbooks. She suggests that beginning artists make "millions" of these little drawings just to improve their ability to see value.

For this piece she did a very small color study, far right, in order to develop a color scheme that would accurately reflect the values of the composition.

In the finished painting she changed the blue background to brown, but kept the values true to the original studies. Even in the final stages of a painting, she will refer to the thumbnails to see if her values are remaining true to her original plan.

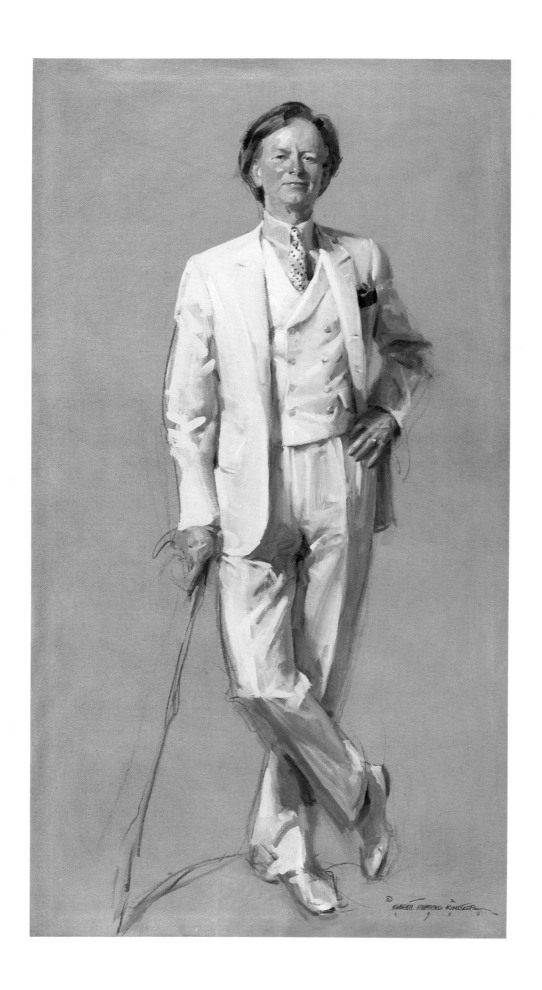

Chapter Two

Tonal Value and Color

Color is made up of four components: hue, intensity, temperature and value. Hue is the pigment, what we usually think of as the color—the red or green or blue. Intensity is the brightness. Temperature is the warmth or coolness of the color. And value, the fourth component, is the lightness or darkness. Every color in a painting has all four elements, but the one we are concerned with here is value.

There are some colors that we think of as intrinsically light or intrinsically dark. Asked for a light color, we might answer yellow, pink or lavender; a dark color, blue, purple or green. But except for black and white, no color has an intrinsic tonal value. Value exists in relation to other values.

Generally we think of yellow as light, but in a painting or a section of a painting where the colors are yellow and white, yellow is the darker color. Sometimes blue is a dark color, but there are times when a very light blue fills a sky or a woman's dress. Within one painting there can be many different values of blue, from very dark to very light.

Color Values

In painting, there is no light value without a darker value to go with it. There is no dark value without a lighter value to show it against. So in planning the values of colors, one must consider the values of *all* the colors.

Many artists start with either the darkest or lightest color value that will appear in the painting—a deep purple, for instance, or a very light green. This initial color is used to key all the other colors. If the purple is established first, then every subsequent color will be related to that color. This is called the *color key*.

Doug Dawson starts a painting by selecting three color values—a light, medium and dark—and then dividing the total design into areas of those three colors. He says that the colors themselves are not nearly as important as the values. In *Taxi on a Snowy Night*, the dark is a deep umber; the light is a very light yellow; and the middle tone is ochre. As he develops a painting, he adds more colors to those initial three, but those remain the basis of the composition.

Dawson doesn't worry if the sky is really brown. In his night painting, he knows that the sky is dark and any dark color will work against the bright highlights of glowing headlights in the snow. It is the relation of the values, not the colors themselves, that gives us a sense of the painted scene.

Value relationships also affect the way that colors appear to our eye. If you place two colors of contrasting value next to each other, they will appear very distinct. For instance, if you paint a light green against a dark red, the two colors will be obviously separate.

However, if the values are the same or nearly the same, they will appear to blend. This is true even with colors that are as different as the complementaries red and green. Put strokes of a medium red next to strokes of a medium green; stand back from the painting and the colors will optically blend to a medium gray color.

Taxi on a Snowy Night
Doug Dawson
Pastel, 17″ × 18″

Dawson begins a painting by dividing the image into large shapes of three color values. He used a dark brown for the dark shapes at the top, bottom and right. For the middle value across the center of the composition he used a medium ochre, and for the light values of the headlights he used a light yellow intensified by white.

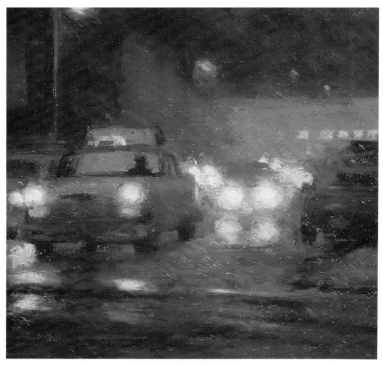

Saturday Afternoon
Mark Mehaffey
Watercolor, 22″ × 30″

Mehaffey creates each area of color value in his paintings by spraying on tiny dots of watercolor of many colors. The various pigments in any section of the painting blend together optically because they are of similar values.

The "Right" Color

There is a tendency among beginning painters to think that there is a "right" color for any given subject. They look for the right red for an apple, the right yellow for a banana. They are sure there is one right skin color if they could just learn to mix it.

Actually, there are many different and unexpected colors that can be used in any section of a painting, and as long as the value and temperature are appropriate, the hue doesn't much matter. Jody dePew McLeane creates the various areas of her paintings with individual strokes of color that blend visually. In *Sanford's*, she painted the skin of the figures with red, orange, purple and green.

Classical painters also adjust colors to suit the value needs of a painting. Look at *Rachel*, by Deborah Deichler. Every section of the skin is composed of many colors—reds, yellows, browns—going from light areas with almost no pigment to very dark, almost black, areas in the shadows. In the black-and-white photo you can see that it is, in fact, the use of values that makes the figure seem solid and lifelike.

Sanford's
Jody dePew McLeane
Pastel, 20" × 24"

Because she is most concerned with the expressive quality of her paintings, McLeane chooses colors for their emotional impact rather than their "correctness." She says that if the values are right, almost any color will work, even for skin tones.

Rachel
Deborah Deichler
Oil, 22½" × 15¼"

Deichler has found that to paint realistic looking skin tones, it is necessary to use many different colors rather than one basic "skin color." In the black-and-white photo you can see that the values range from almost black to almost white.

Black, White and Gray

Pure black is such a powerful color that many artists avoid it altogether. It is possible to create the sense of black without ever using black in your paintings. By placing a very dark brown, gray or blue against very light colors, the dark color can actually look black.

However, some artists like to use the full range of values, pure black to pure white and every value in between. One of those artists is Kendahl Jan Jubb, who uses the contrast of black and white against her brilliant watercolor pigments to provide maximum drama in her compositions.

The way that Jubb works with black in her decorative paintings is to place all of the other colors on the paper first. Then she paints opaque black where it will make the other colors appear stronger. When she uses black, she places bits of the dark value throughout the composition to maintain balance in the design.

Artists also have differing views of the use of pure white in paintings. Many watercolorists leave unpainted white paper for the lightest sections of their paintings. But in other media, artists tend to think that pure white should be used sparingly. Pastel artists often work on colored paper, and oil painters often work on toned canvas so that they won't have awkward bits of white showing through.

Sally Strand is known for her striking use of white. Many of her subjects are tennis players or lawn bowlers dressed in white, but she rarely uses white pastel except for placing the brightest highlights. She creates the impression of white cloth in sunlight by placing strokes of light blues, lavender, green, yellow and pink against darker background colors.

Perhaps the richest and most underrated color available to artists is gray. There are actually many different grays. Besides the simple gray made by mixing black and white, additional grays can be made by combining two complementary colors. The combinations of red and green, blue and orange, and purple and yellow each make a different gray. One of my favorites is a combination of Hooker's green and alizarin crimson for a rich dark gray; for lighter grays I add varying amounts of white to that mixture.

In her series of acrylic paintings, *The Homeless*, Pat Berger wanted an overall gray look to the work to reflect the social conditions she was portraying. So she developed much of each image with a variety of gray tones, adding colored washes or accents of opaque color near the final stage of each painting.

The advantage of working with grays is that it is easier to distinguish the comparative values. You are not distracted by strong hues.

White Tigers
Kendahl Jan Jubb
Watercolor, 25" × 22"

Jubb uses the full range of color values in her paintings, from pure black to pure white. To keep the black from overpowering the other colors, she intersperses it throughout the entire composition.

Exercise
Color Without Value

Select three to five colors of the same value. They can all be light, medium or dark, but the value of all the colors must be the same. You can check this by squinting at the colors together, or by checking them against your gray scale, or by looking at them through a piece of transparent red plastic. Then compose and paint a small painting using just these colors with no change in value.

As you paint, do not dilute or in any other way change the colors so that you alter the value. The painting should have one overall value—all light, all dark or all medium tones.

Study the finished painting to see the characteristics of a painting that has no value changes.

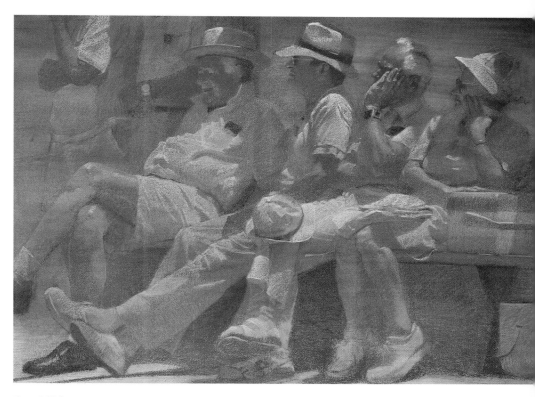

Court Side
Sally Strand
Pastel, 30½″ × 41½″

There are many white objects in this painting—hats, shoes, clothes, hair. However, very little, if any, white pastel is used in the picture. Instead, light blue, lavender, green, pink and yellow strokes make up the "white" areas. These colors appear white because of the contrast with the darker, warmer background.

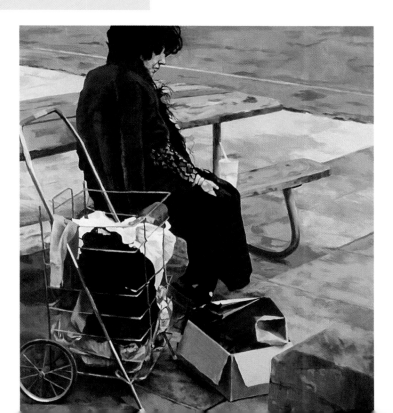

The World of Mildred
Pat Berger
Acrylic, 48″ × 40″

The color key for this painting of a homeless woman is gray, a color suited to the mood as well as the look of the subject. Berger mixes her grays from a variety of complementary colors rather than just black and white.

What Comes First?

There are three basic approaches to color and value in a painting.

Monochrome Underpainting.

The classical way to compose a painting is to develop the value before attempting to add color. Traditionally this was done by blocking in the painting with brown. Often the canvas was toned by rubbing a very thin wash of brown onto it. Then important lines and forms were indicated with strokes of the same brown, creating a monotone underpainting that showed the placement of all the major shapes and values.

Any single color could be used as an underpainting—gray, blue, purple, red, green. To be sure your monochromatic underpainting will harmonize with subsequently applied colors, keep in mind the subject and the proposed palette for the painting. After the structure of the painting is laid out with the single color, add the colors that will complete your painting. You can paint onto the underpainting while it is still wet and let the initial color blend with later paint strokes. This will automatically add value to your second layer of color.

Or you can wait until the underpainting is dry and then paint over it with transparent glazes. Some artists start with transparent glazes and gradually use more opaque colors, using the most opaque paint for final accents. Applying opaque paint early will hide the values that you have created.

Color Underpainting.

The second approach to composing with color and value is to first lay in the local color without regard to value, a red for the apple, green for the pear, blue for the bowl. Once the local colors are blocked in, you can adjust the values, making one part of the apple darker, another part lighter and so on.

Direct Painting.

The third approach to composing with color and value is to paint color values directly. This means that each stroke you put down will be concerned with both the color and the value that you want to create in your final painting. Some artists build the color value slowly with layers of transparent glazes; others put down the exact color values in the first layer of paint. Scott Prior is one artist who starts at one corner of the painting and simply covers the canvas with the exact color value.

For the beginning artist the most effective approach is to begin with a monochromatic underpainting. Develop the value shapes first, and know where your lights and darks will be placed before you begin to add color. Then add the color in transparent glazes over the value design.

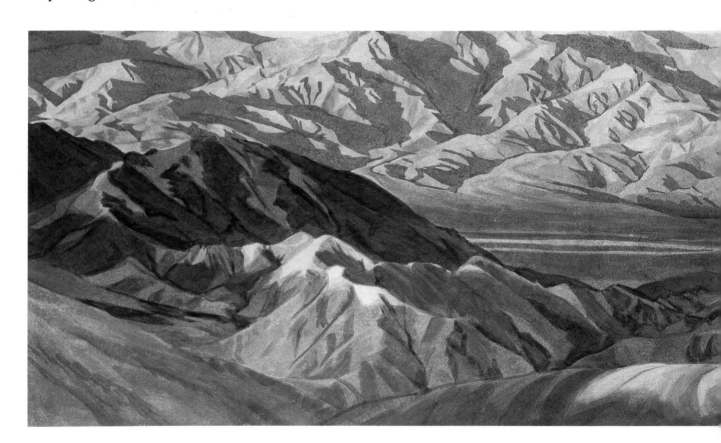

Playroom Corner
Scott Prior
Oil, 46" × 42"

Before Scott Prior begins a painting, he explores the subject through sketches, photos and extensive observation. He is confident of the exact color values he wants to create. This realistic image was done with one layer of paint and almost no reworking.

Zabriskie Point
Susan Shatter
Watercolor, 32" × 108⅝"

Susan Shatter works directly in color values rather than dividing value and color. Before she begins her monumental landscapes, she works out the color values in small studies.

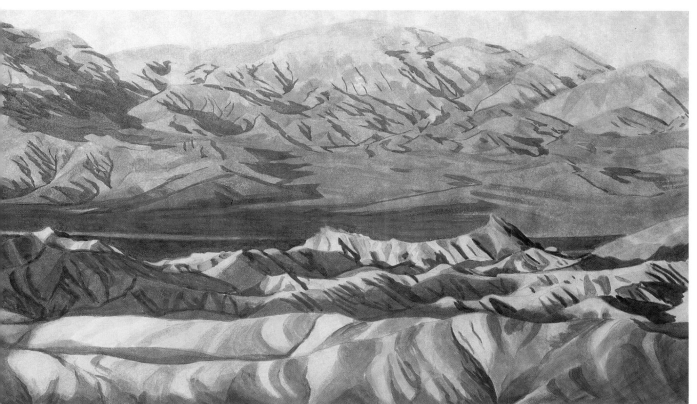

From Value to Color

Richard Schloss paints landscapes that glow with light and atmosphere. He uses a combination of glazing and scumbling to create color that seems alive. Schloss is an artist who develops value first in a painting. Only after the lights and darks are set does he build up his glowing color.

The use of value is crucial to Schloss in developing both light and space in a painting. When he picks a subject, it is because of the way light falls on the scene. The interplay of light and shadow is what challenges him as an artist, and that interplay is primarily expressed with value.

Three-dimensional space is also very much a function of value. In the foreground, contrast is most pronounced and there is greater distinction between objects and details. As things recede, and more and more atmosphere separates the eye from the object, everything approaches a middle gray; neither the lights nor the darks are as extreme.

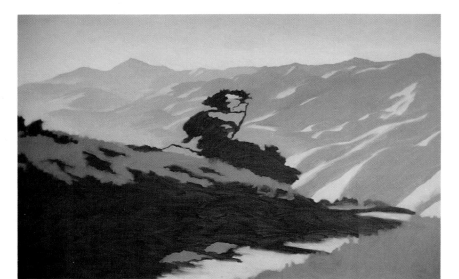

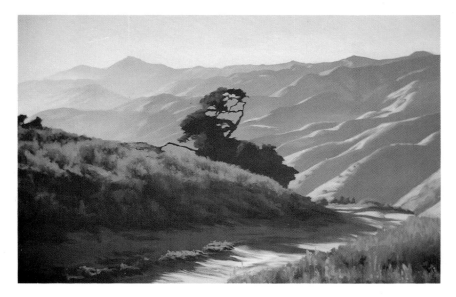

On El Camino Viejo
Richard Schloss
Oil, 32"×48"

Step 1

The first phase of every painting is a value breakdown of the image painted in blues or grays. "The value comes first. I look at it in terms of shapes or patterns of lights and darks, not hills and trees. It doesn't work to paint details," says Richard Schloss.

Using a medium flat brush, Schloss lays in the value structure of the painting. Before he leaves this stage, he says the image must look like the scene he is painting. This monochromatic underpainting is the map to the finished image.

Step 2

He repaints the entire underpainting, refining the value relationships and adding some detail and color. These colors are chosen to anticipate the yellow glaze of the next step — the areas that are to be green, he paints bluish; the areas that are to be orange, he paints reddish; the areas that are to be gray, he paints purplish, etc. He also exaggerates the contrast because a glaze over the entire painting will lower the contrast.

Step 3

Once the value structure is down, he begins to define the color with transparent glazes that he rubs over the entire canvas. Here, using a rag, Schloss rubs a thin glaze of Indian yellow over everything except the sky. The glazing of transparent colors provides luminosity. Once the painting was dry, Schloss scumbled a few colors over the distant hills to create atmosphere. In scumbling he drags a brush of almost dry paint lightly over a dry area, leaving some of the previous color showing through. He is careful to use colors of similar value so they will blend optically. He also scumbles in the foreground to reduce the harshness of some colors there.

Step 4

Finally he scumbles a few more colors over all, adjusting values and colors and adding details such as trees and grasses.

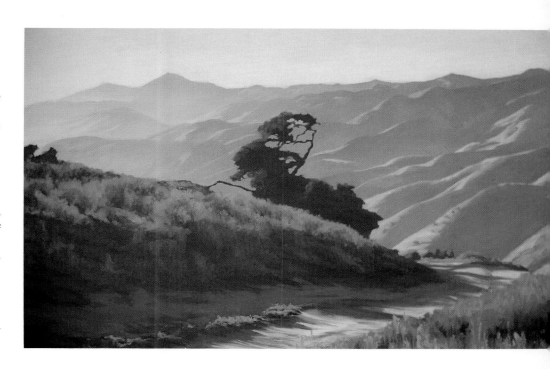

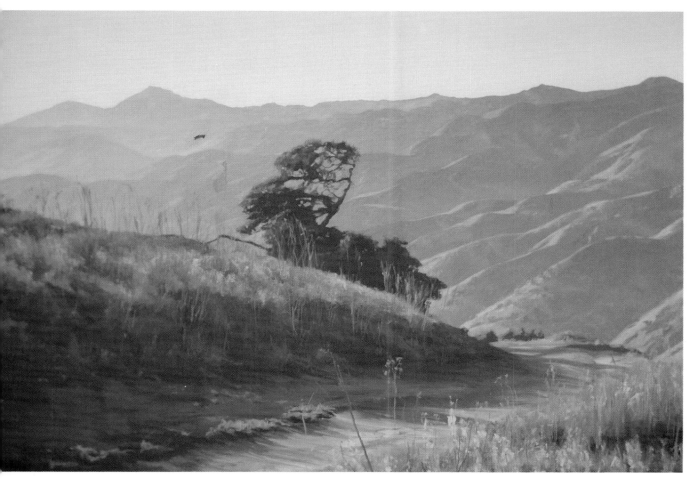

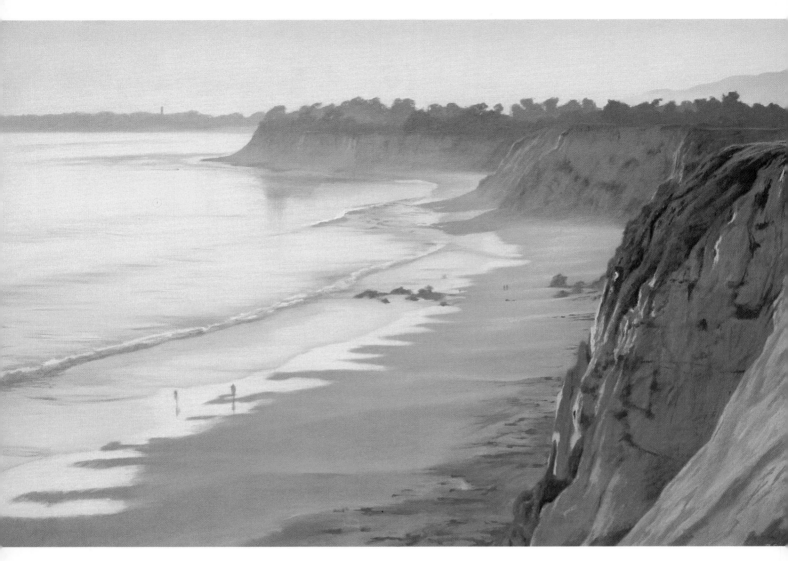

Cliffs at More Mesa
Richard Schloss
Oil, 38" × 57"

Here you can see again how Schloss uses
value to create a sense of receding space.
The value contrast is most extreme in the
foreground with the darkest darks and
lightest lights of the composition. As the
scene recedes in the distance, all the val-
ues change to middle tones.

Coastal Live Oaks
Richard Schloss
Oil, 32″ × 48″

Schloss creates drama in this painting with his use of value. He has painted a dark, shadowy foreground and placed a light, sunlit area behind that. The unexpected brightness behind the foreground makes the composition visually exciting.

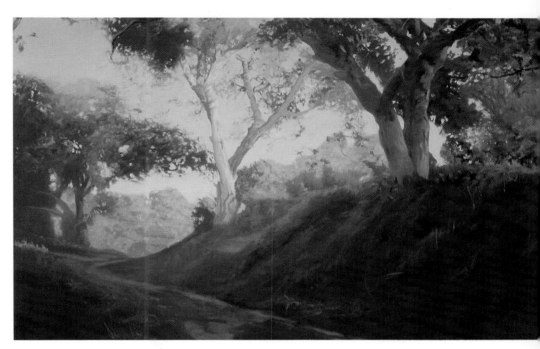

Hillside Near Buellton
Richard Schloss
Oil, 34″ × 52″

A mood of quiet peacefulness sets this painting apart. Schloss has established that mood by keeping all of the values in the painting in the middle range. There are no extreme darks or extreme lights to jar the eye.

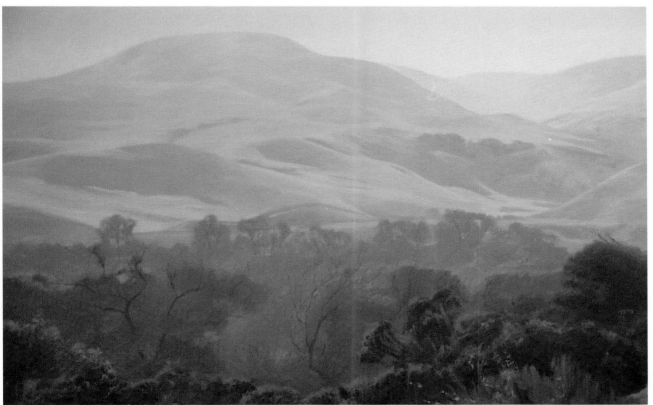

Painting Complementary Values

A single Sandra Kaplan watercolor of florals or floral landscape subjects sometimes covers an entire wall. Painting on such a large scale with an unforgiving medium like watercolor, Kaplan needs some way of controlling the composition. She uses a monochromatic underpainting as the initial value structure that holds the image together.

The underpainting is done in a color that is a complement to the dominant color planned for the piece. After the values are set, she builds up the color with transparent washes.

By painting the values first, Kaplan is able to work more freely with subsequent colors, knowing that the design of the piece is already set. Using complementary colors first gives later colors a greater richness.

Kaplan says about her paintings, "The actual, physical subject is not my primary concern. I like that the lights and darks break up those forms, creating new abstract forms."

Hibiscus With Canna Leaves
Sandra Kaplan
Watercolor, 40" × 60"

Step 1

Working from a slide or from life, Kaplan does a very detailed drawing of the subject in colored pencil. Here she begins the painting by laying down the value relationships. She is planning most of the painting in green, so she uses a complementary warm violet for the underpainting.

Step 2

Next Kaplan paints the lightest flowers so the rest of the painting can be done in relation to those colors.

Step 3

She adds a green wash to the areas adjacent to the flowers. The values are already set, so she is primarily concerned here with color relationships. She then glazes warm and cool greens to establish highlights and shadows.

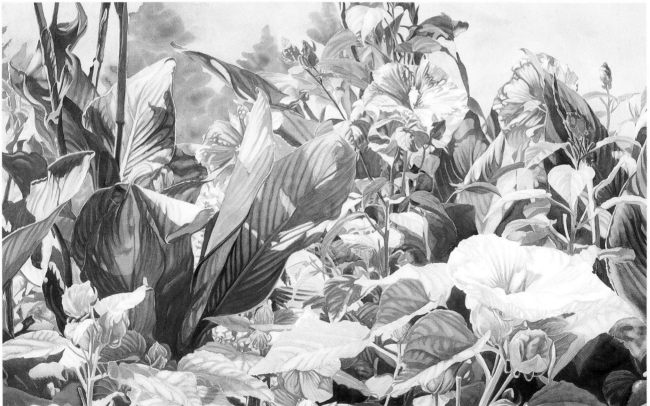

Step 4

With the final glazes applied, the understructure of value is no longer separate, but an integral part of the color values.

Unabridged
Sandra Kaplan
Oil, 5′6″ × 24′, 12 panels

Photo collages

For this 24-foot-long painting Kaplan decided to paint a 360-degree view of a Japanese garden. Since there was no way to get one reference photograph of the entire scene, she shot numerous photos and pieced them together in a collage of the total view. She used this collage as a reference for planning her composition.

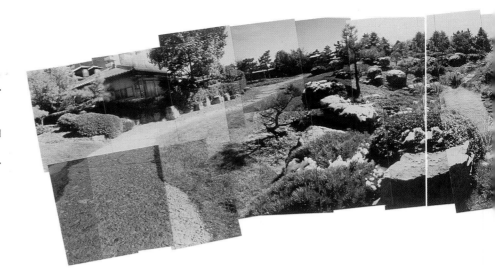

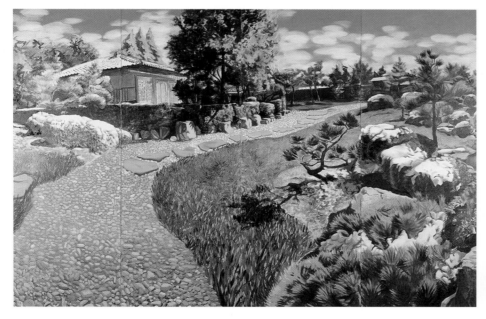
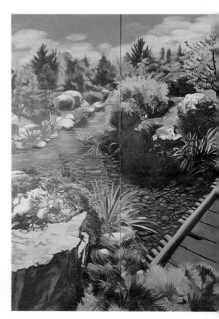

Final painting

In the finished painting you can see that while Kaplan is not concerned with naturalistic color, her painting still has a sense of solidity and depth because of her use of value to define light and form.

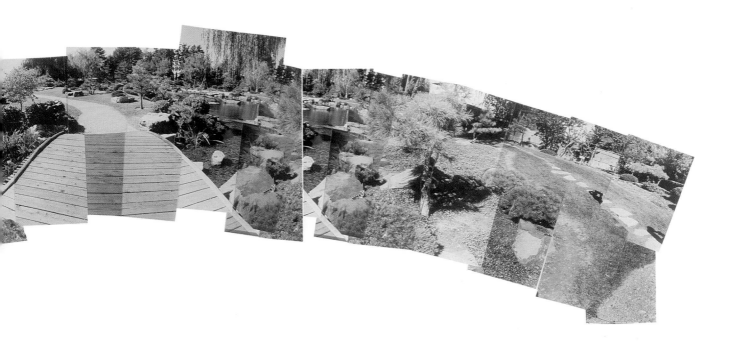

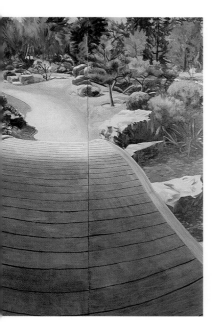

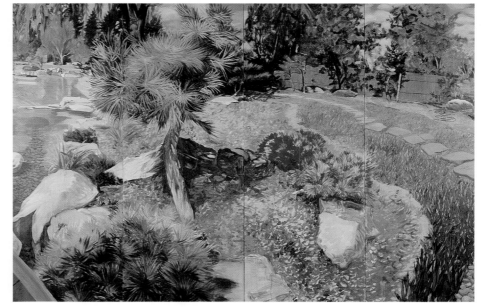

Color Values

"While I am aware of and sensitive to choice of colors in composition, I strongly consider, even emphasize, the importance of values—the lightness or darkness of colors—as a key to color relationships," says Everett Raymond Kinstler, master portraitist.

From the beginning of a painting Kinstler thinks about exact color values. When he blocks in a face, for example, he boldly puts down strokes of the color value he anticipates in the final painting.

His outdoor paintings are quick and spontaneous color sketches to capture the moment in nature. But when he paints in the studio, he devotes time to preplanning the composition and color relationships, often doing pencil or color studies.

Before starting the final composition for the portrait on these pages, Kinstler spent several days with the three subjects to determine both the pose and the subjects' personalities. He painted separate oil portrait heads of each as a study for the larger painting.

Kinstler works directly with color values. From the beginning of the painting, his strokes establish both color and value as close to the finished painting as possible.

Thomas Lewis, George Porter III, M.D., Frank Riddick, M.D.
Everett Raymond Kinstler
Oil, 82" × 77½"

Step 1

Kinstler begins by blocking in the figures on top of his charcoal drawing. From the beginning he establishes the light and dark areas within each figure.

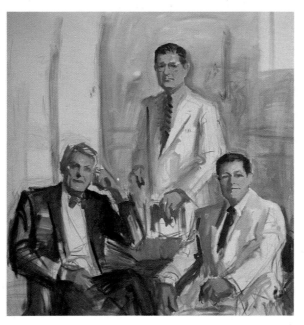

Step 2

All three figures and the background are developed simultaneously. Initially he focuses on general shapes; he will refine shapes and details as he goes along.

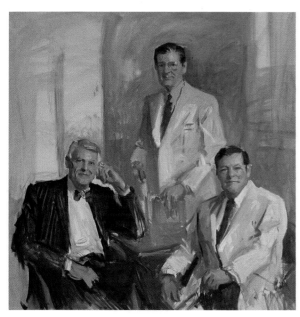

Step 3

Colors and values are coming into focus. Details are being suggested. Faces and gestures are being sharpened.

Step 4

In the final painting the composition remains basically the same as it was established originally. The shapes have been refined, the color values adjusted and the details added.

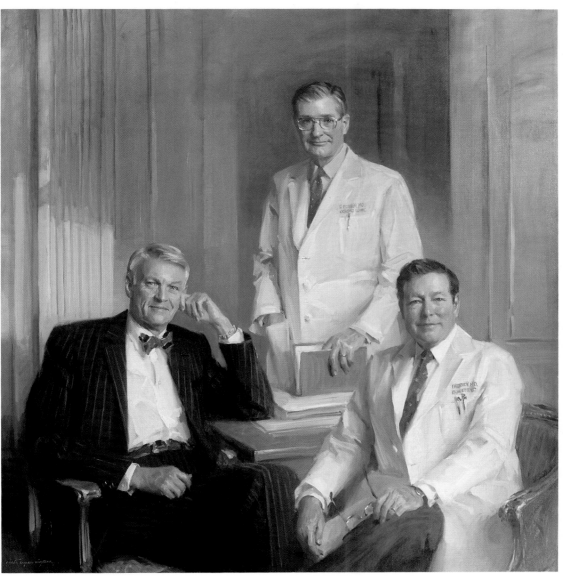

Finding the Color Key

For every painting, Pat Berger plans a color key. The key is the dominant color or the color you see when you look at the painting through squinted eyes regardless of how many colors the artist used. The key may be chosen because of the look of the subject—green for cacti or garden scenes—or to express the meaning or mood of the piece—blue or gray for images of urban homeless.

Berger explains, "If I'm doing a blue painting, for instance, the key is blue, but within that are greens, grays, a little bit of yellow and white. No matter what colors I use, when I squint my eyes, it will be a blue painting."

In a color keyed painting the col-ors are more harmonious; no color jumps out more than the others. Also, the ability to control values is greater. In a green painting the artist already knows that most of the shapes will be green, so instead of worrying about which color to choose, she can focus on how dark or light that green shape should be.

Berger begins her paintings by laying out the value composition in charcoal. She says, "In every painting there is a light, a middle tone and a dark. In a composition that is going to work, you have to incorporate all of these values into a kind of rhythm."

Once she has laid out the basic value structure, she builds the painting up slowly so there is one layer over another, until she gets to the finished result. She has a good idea of the color key she wants from the beginning and simply works until she gets to that.

Berger works all around the painting simultaneously, establishing the large, flat areas first and leaving the details for the end. If she has any doubts about how the values are working, she sets the painting aside for a while and goes back to it later with a fresh eye.

She knows the painting is complete when everything fits together and it has a glow to it, when any more strokes of paint would be superfluous.

Shore Acres
Pat Berger
Oil Sticks, 22″ × 30″

Step 1

On smooth bristol paper Berger lays in the landscape with charcoal pencil, then uses her finger to smudge and create the dark patterning. She cuts out lights with an eraser and sprays the final drawing with charcoal fixative.

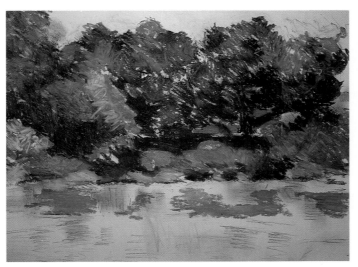

Step 2

The color key for this painting is green, so she starts with the green areas. She maintains her original value pattern with various greens and adds deep orange in the trees as an accent.

Step 3

She covers the entire paper with strokes of oil stick. To change values or smooth out areas, she goes over one layer with another layer of oil stick. For blending she uses a colorless oil stick, a dry brush or a finger.

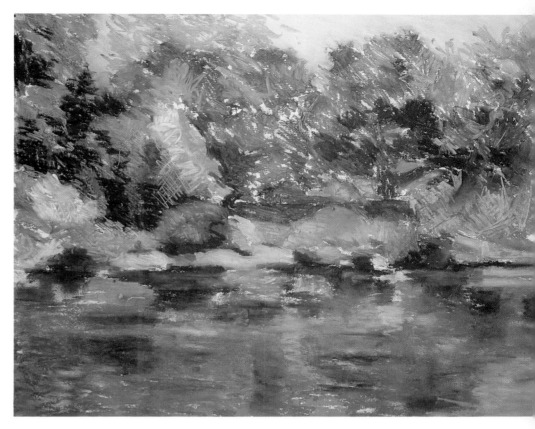

Step 4

In the final step Berger solidifies the color and adjusts values. Where a value is too dark, she either scrapes off the color or simply paints over it with a lighter value.

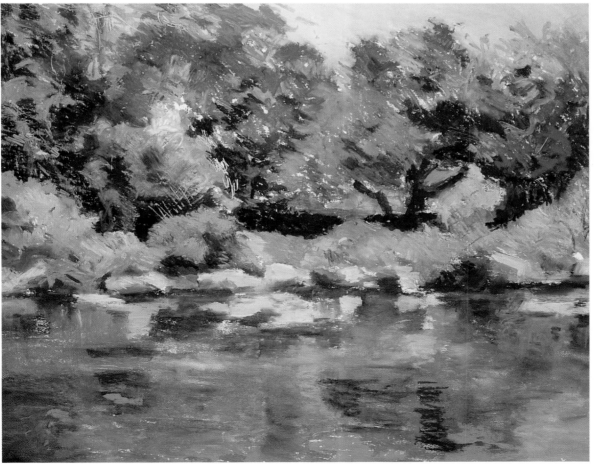

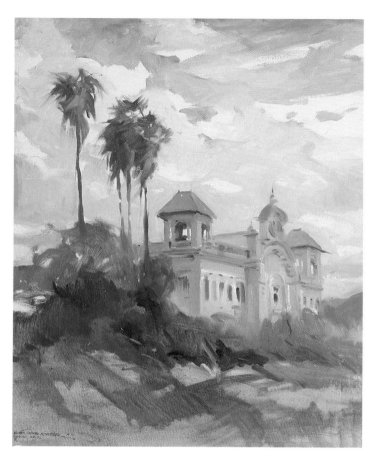

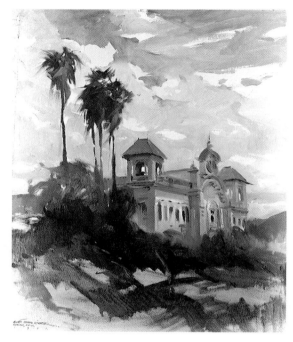

Mexico
Everett Raymond Kinstler
Oil, 30″ × 24″

Kinstler works directly with color values, which means that each stroke of color he puts down is also chosen for the value it has. That is especially apparent in this alla prima landscape. The color was put down in quick, single strokes with little layering. The color works quite well and so does the value pattern, as can be seen in the black-and-white photo.

Tree Patterns, Portugal
Everett Raymond Kinstler
Oil, 26″ × 32″

What keeps this painting from appearing to be just a random assortment of strokes is the pattern of light and dark shapes. Squint your eyes to see the circular value composition. When Kinstler chooses color for each stroke, he also considers how light or dark that stroke has to be for the overall composition.

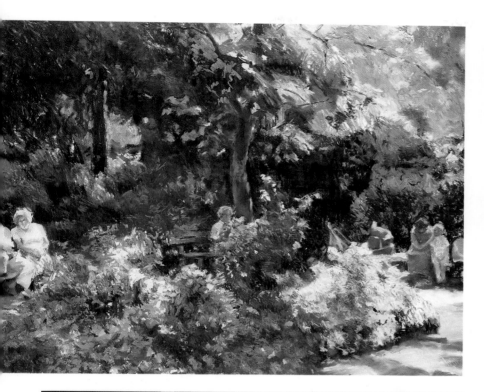

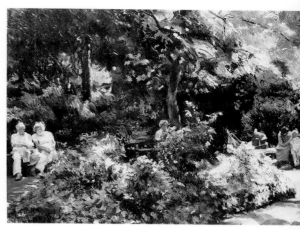

Vogelpark, Walsrode
Pat Berger
Oil Sticks, 30" × 40"

This is a lively looking painting because Berger used active strokes and a full range of values. The painting goes from white to black, with the extreme lights and darks sitting next to each other in many spots.

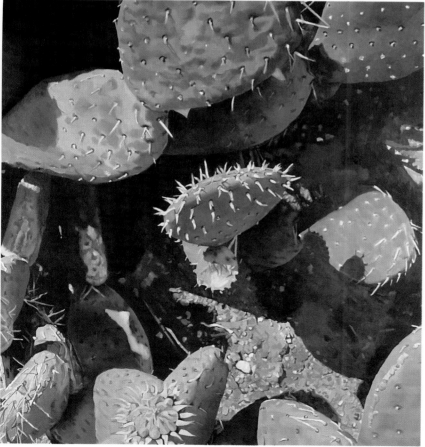

Cactiscape
Pat Berger
Acrylic, 60" × 54"

What gives this painting its visual punch is the fall of light and shadow on the subject. Turn the image in any direction—upside down or sideways—and you still see an exciting pattern of lights and darks.

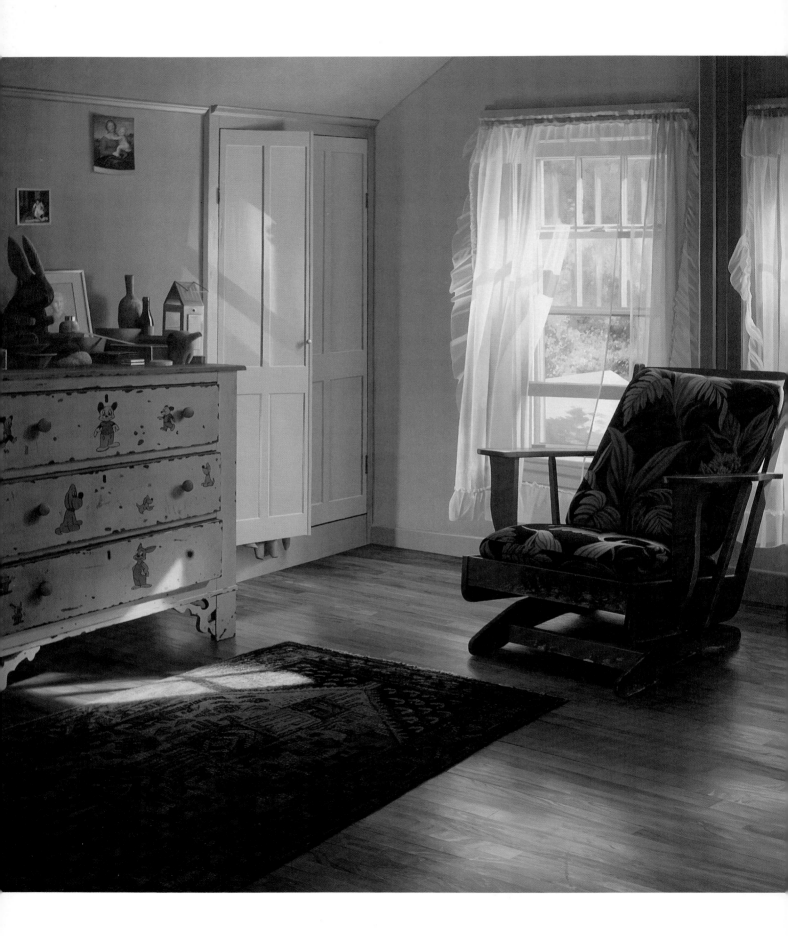

Chapter Three

Tonal Value and Light

Bedroom Corner
Scott Prior
Oil, 42" × 40"

Prior's evocative paintings get their mood from the use of light. The dark values of the rocker placed next to the lightest values of the windows create a quiet drama, a feeling of suspended time. Compare this painting to the one on page 23, also by Prior.

Vision is made possible by light, and value is the expression of that light. Where there is little light, the values are dark. The absence of light is conveyed by black. The presence of light is shown with "light" values. When a scene is flooded by light, all color disappears, and we are left with white.

The presence or absence of light is a vital element in the design of a painting, but light affects art in other ways as well. It is the way light falls on an object that gives it three-dimensional form, and gradation of light helps establish distance in space. The contrast between light and shadow provides drama and emphasis in a painting. And all of these aspects of light are expressed in your use of value.

Morning Coffee
Jody dePew McLeane
Pastel, 32" × 40"

What makes this a strong composition is the intense light source shining through the window. The silhouetted figure, dark walls and cast shadows contrast against the bright areas of the painting in an intriguing pattern of abstract shapes.

The Light Source

Perhaps the first thing you need to establish when planning the lights and darks in a painting is the light source. Is the source natural or artificial, bright or dim? And where is that source in relation to your subject?

The light source sends rays of light into the atmosphere to light whatever those rays fall on. The area those rays fall on first will be brightest. The farther from the source the rays fall, the dimmer those rays will be, so the farther you get from the light source, the darker the values will be. Whatever blocks the light rays will cause an absence of light or a shadow.

If your light source is the sun and the sun is to the upper right of your subject, the brightest areas of the subject will be on the upper right. The shadows will fall on the left, particularly the lower left. What does this mean to your use of values? If the light source is on the upper right, the lightest values will be on the upper right and the darkest values will be on the lower left.

Many artists set up their compositions with a single light source and divide the image into a light side and a dark side. Rarely is the fall of light that simple. Even with a single light source, there will be reflective surfaces within the subject that become minor light sources. Many times there is more than one major light source, for example, a lamp overhead and a window can both be light sources in a painting.

Late Afternoon Sunlight
Scott Prior
Oil, 54" × 60"

What makes this painting intriguing is the unexpected arrangement of values. The area closest to the viewer, the side of the counter, is the darkest section of the painting. The distant areas seen through the window are much lighter. The subject definitely is the sunlight itself as it glows through the plants and around the objects in the window.

Light as a Subject

Learning to see light can be a life-long exercise, and for many artists, capturing light is their most rewarding challenge. Often artists are not so interested in the objects they paint, but are more concerned with painting the fall of light on those objects. The light itself is their subject.

Sometimes it is the pattern of light and dark shapes that intrigues the artist. Cast shadows can provide visually fascinating shapes as well as adding drama and mystery to a scene. Cast shadows are rarely exact silhouettes of the objects that cast them; they are distorted by the angle of the light source or by falling on irregular surfaces. Shadows cast by even a simple geometric object can assume fantastic, irregular shapes. Early morning and late afternoon sun casts wonderful long shadows because of the low angle.

Light itself can also fall in interesting patterns. Think of sunlight falling through the panes of a window or the leaves of a tree. The bits of sunlight create a pattern of lighter value on whatever objects they hit. You can show these patterns by changing the values of the areas where there are shadows or patterns of bright light. Start with an underpainting of all the lights and darks in the composition before you develop local color. Put down the pattern of light and shadow first and then add the color in transparent glazes.

You can also create the patterns by painting directly with color values. As you paint an object, mix and paint different color values for each section that is affected by the fall of light or shadow. For example, mix a darker red for the part of the apple that is in shadow and a lighter red for the part that is in sunlight. The colors themselves will show where the apple's appearance is altered by bright light or shadow.

Hedge and Shadow
Eleanore Berman
Oil, 60" × 60"

The power of this painting is in the value composition created by the pattern of light and shadow. Look at the repeated oblong shapes in the highlights of the upper half of the composition, and the same oblong shapes in the cast shadows in the bottom.

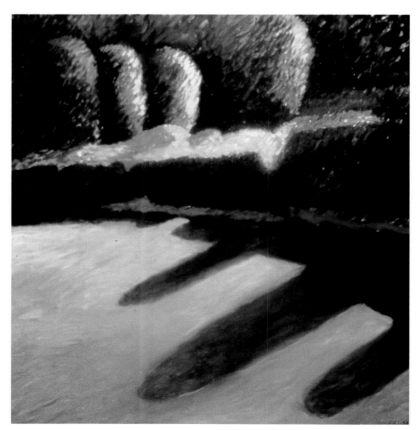

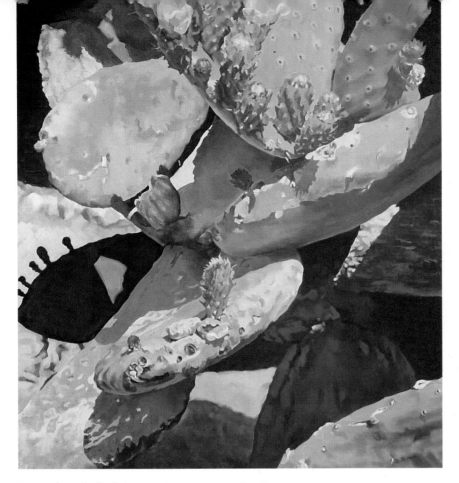

Types of Light

The type of light can be an interesting subject. The light at dawn has a different character from the light at noon, and that is different from the light at night. There is a difference between candlelight and window light. Rain, fog and snow each create a distinct kind of light.

Look through the paintings presented in this chapter. Which have gentle light? Which have harsh light? Which light connotes a particular time of day? Which light is specific to a location? How are those differences in light conveyed through value? Look at the black-and-white photo of *Las Tunas* by Pat Berger. Berger's cacti are painted in bright sunlight, so the light shapes are very distinct from the dark shapes. The value contrast is bold and dramatic, with very dark shapes set against very light.

The values in *Palms and Mission* flow gently from one into the other. The only sharp contrast is the dark, silhouetted tree in the corner, but even that has softened edges. The light that is given by haze is a soft, diffused light with all the values in the middle range.

Las Tunas
Pat Berger
Acrylic, 48″ × 40″

Berger painted these cacti in bright sunlight, which makes the value contrast in the piece very dramatic.

Palms and Mission
Richard Schloss
Oil, 30″ × 45″

Atmospheric conditions have a great effect on the light and consequently the values in a painting. This is a fairly bright painting overall, but the values tend toward the middle because haze deflects the light rays that would create strong highlights and deep shadows.

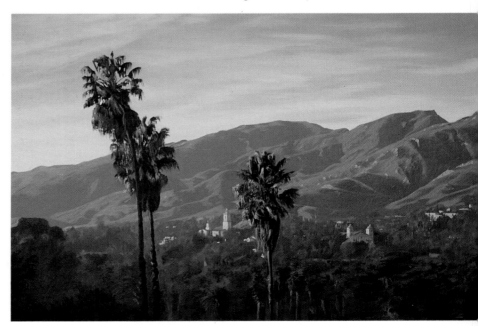

Create Drama With Light

Just as in the theater, light in paintings can be used to create drama. Shine a spotlight on someone onstage and the audience automatically looks there. It is the same in a painting.

In her painting, *Eurydike*, Deborah Deichler shone a spotlight on the figure, giving the young woman a sense of mystery and drama. This is intensified by the general darkness of the background. An additional mysterious element is created by the ominous cast shadow on the mantle.

Whenever the value contrasts in a painting are intense, the painting will have more drama than one in which all the values are in the middle range. If you want to create a mood of peace or calm, eliminate all strong value contrast. Keep the light diffused so there are no strong highlights or shadows, and your painting will automatically be quieter and more peaceful.

Another way to affect the mood is with the total amount of light value or dark value used in the painting. A scene where there is very little light, and consequently the values are primarily dark, will seem heavier and more somber than a lighter painting. By contrast, a painting that is flooded with light so the values are all on the light end of the scale will seem happier and friendlier.

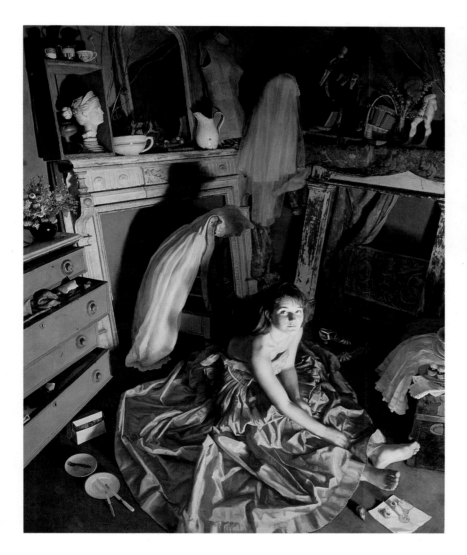

Eurydike
Deborah Deichler
Oil, 5' × 4'

Deichler's intent was to create the drama of a lighted figure in a darkened interior. Deichler says, "If we could paint with light, we'd have more success, but we use pigments. So thinly painted areas, using light bouncing back off the ground and right through the paint, add to the range of lighter values offered by oil pigments."

In the black-and-white photo you can see the sense of theatricality and mystery that is achieved with the use of value. The model in the spotlight is the star and the objects and shadows behind her look dark and somewhat ominous. With different lighting and values this same scene would have a totally different mood.

Evening Hues
Robert Frank
Pastel, 7" × 10"

The use of light gives a focal point to this composition. The central shape of bright yellow catches the eye because of the contrast of darker values in front of and behind it.

Dusk in the Canyon
Susan Shatter
Watercolor, 35⅜" × 96¾"

This painting is of a particular moment in time in the Grand Canyon. If Shatter had painted it just a few hours earlier or a few hours later, the scene would have shown totally different value shapes because of the change in light.

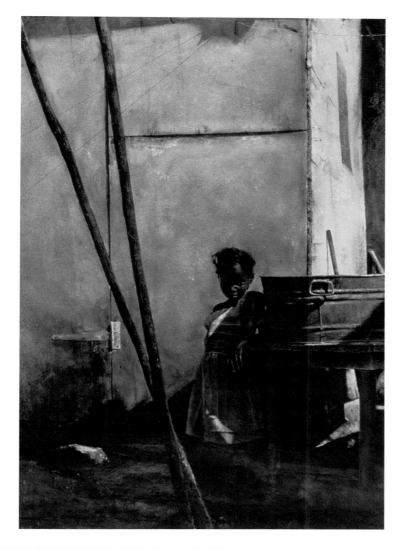

Clothesline
Stephen Scott Young
Watercolor, 29¾" × 22"

The best way to really see the value composition of a painting is to turn it upside down so you're not distracted by the subject matter. Do that with this painting. You'll see the unusual pattern of very light shapes that Young created within this image.

Exercise
Changing Light

Pick an outdoor scene. It can be rural or urban or even a still life set up outdoors. Photograph the scene just as the sun is rising in the morning. Photograph the same scene at two-hour intervals throughout the day. Photograph exactly the same scene from exactly the same location without changing the shutter settings on your camera. This exercise will work best if it is a sunny day.

Have prints made of your photographs and lay them side by side. Notice how the scene gets lighter and darker during the course of the day, and notice how the highlights and shadows shift as the sun moves.

Going to the Source

Richard Pionk arranged his painting studio around the light source. He prefers working with the constant illumination of a north light, so he places his subjects by his northern window. To make the light look natural, like sunlight from above, he blocked off the lower portion of the window.

Having a single light source gives Pionk's work drama and solidity. His studio is dark except for the stream of light through the window, so the highlights and shadows are intense. Whether he is working with a still life or a human figure, the light is of paramount importance.

"Light and a lot of color is what gives you focus in a painting," says Pionk. "With a still life I may lay it all out in two browns, first developing the values. Then the focus, which may be a peach near the center of the painting, I do with light and a lot of color, forcing the color beyond what is natural to bring the eye to that point."

With figures he is also first concerned with values. Because he uses a single light source, he is able to develop a light and a dark side. From the first charcoal sketch, he has placed the values. He uses the shadows to create the three-dimensional form of the subject.

Mary
Richard Pionk
Pastel, 24" × 19"

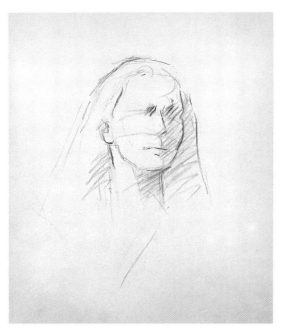

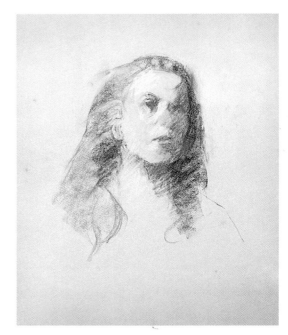

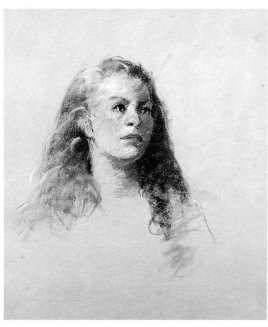

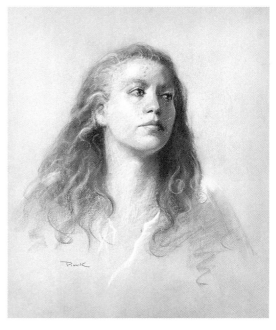

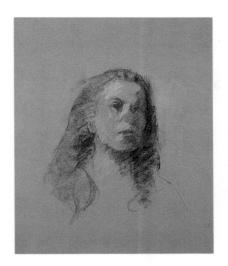

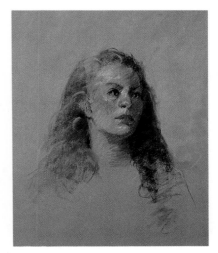

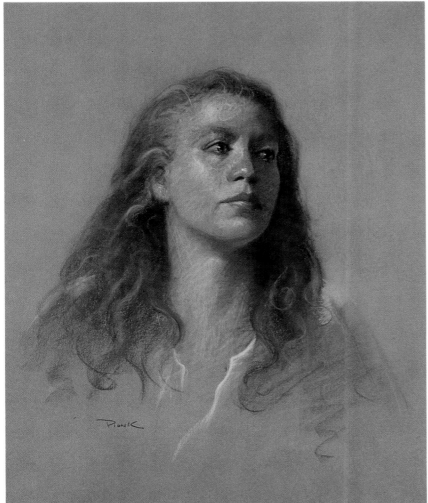

Step 1

Pionk uses a single light source to illumi-nate his model, so he is able to divide the subject into a light side and a dark side. He begins by marking the basic shapes and shadow areas with charcoal.

Step 2

With his first pastel colors he establishes the light and dark areas of the face and hair. In the black-and-white photo you can see how he begins with large value areas rather than concerning himself with details at this stage of the painting.

Step 3

He intensifies colors and refines shapes, but he is still working with a few large value areas. Throughout the painting pro-cess it is obvious that the light is shining onto the model from the left.

Step 4

In the final stage Pionk continues to refine colors and shapes. His finished portrait looks real and solid because of his authori-tative placement of light and shadow.

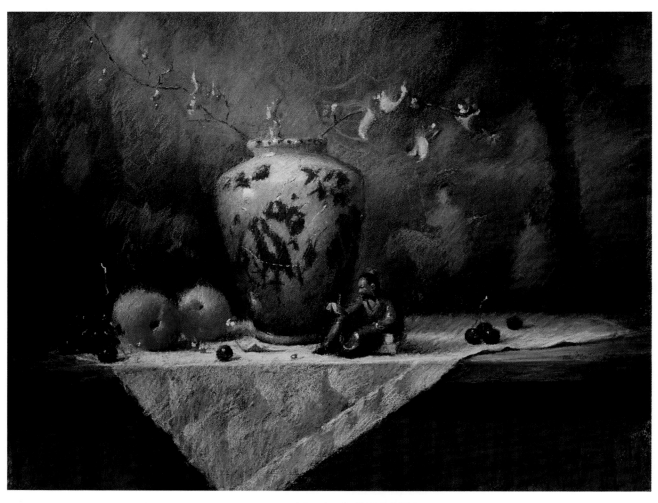

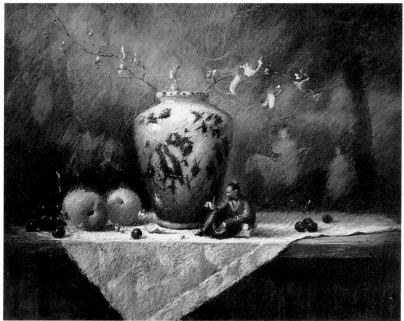

Still Life
Richard Pionk
Pastel, 30" × 40"

As with all of Pionk's paintings, the light in this piece is shining from an unseen window at the upper left. He has created a line of light from the upper left to the middle that draws the viewer's eye into the painting. The focal point is created by the strong highlight on the light-colored vase.

Pink Roses
Richard Pionk
Oil, 12" × 9"

Placed against a background of dark value, this gleaming glass vase and roses become even more luminous. Notice how Pionk plays with light and the reflections on and from the vase.

Onions and Brass
Richard Pionk
Oil, 12" × 15"

This simple composition is made compelling with dramatic lighting. Because the entire background is dark, the tabletop jumps out at the viewer. Strong highlights and shadows make the onions interesting and the pot draws our attention because of the bright reflections.

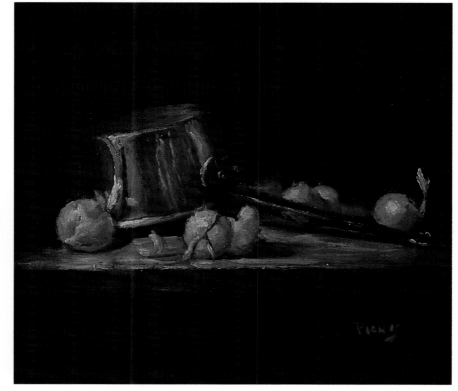

Painting the Right Time

Pat Mahony will wait days for the light to be just right for a painting. She is not interested in the subject itself, but rather the mystery created by strong light and shadows falling across the subject. She wants the viewer to wonder what is going on in the shadows.

For years Mahony painted primarily architectural facades. Then she moved to a rural setting and began working with landscapes. Even though the subjects are different, she is still concerned with the drama of light and shadow. She paints her landscapes on site, after predetermining the lighting conditions she is looking for. For the most dramatic shadows, she looks for subject matter early in the morning or late in the afternoon. She says that winter is the best time for drama because the sun is lowest in the sky at that time.

Taos
Pat Mahony
Watercolor and Gouache, 7½″ × 12¼″

Step 1

After locating the main shapes in her composition, Mahony begins with watercolor washes of light primary colors.

Step 2

Continuing to work with primaries, she places all of her darkest values early in the painting process.

Step 3

Then she comes back into the painting with lighter values of opaque gouache, which pick up and blend with the watercolor underneath. She allows bits of transparent color to show through for brilliance and uses the gouache to establish surface texture.

Aspens
Pat Mahony
Oil, 23″ × 42″

Mahony begins her paintings by laying down very intense transparent colors of medium to dark value. Then as she develops the painting, she brings some of those shapes back to light values with opaque paint.

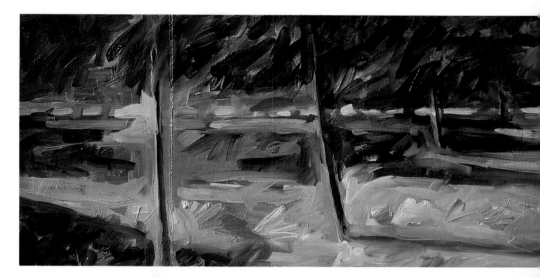

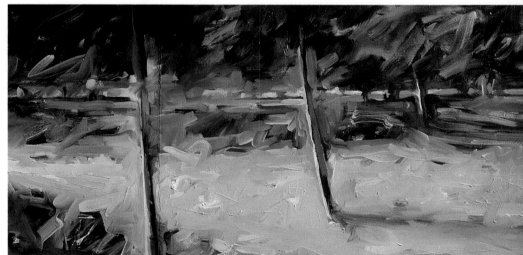

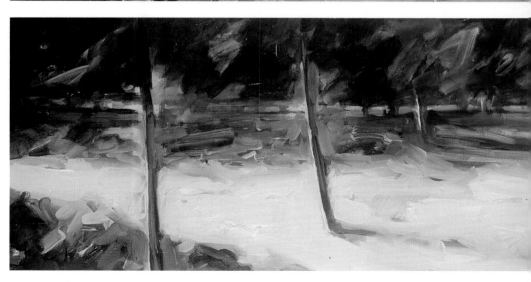

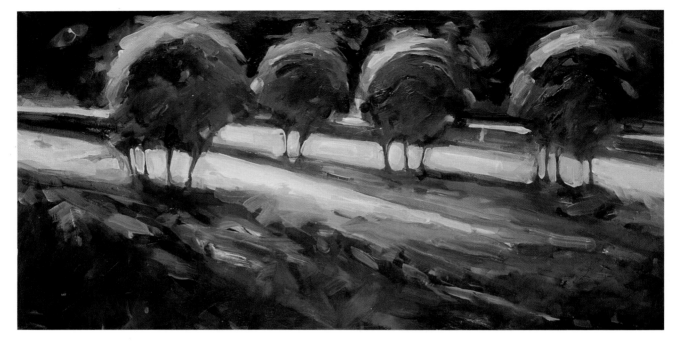

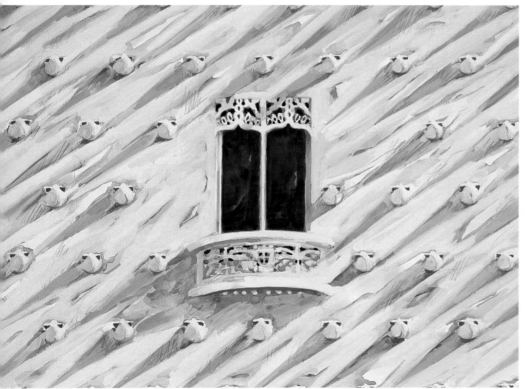

Four Trees—Portugal
Pat Mahony
Oil, 10" × 18⅝"

In Mahony's landscapes she also concerns herself with dramatic lighting. With the foreground and background in shadow, the center of the composition is a series of diagonal stripes of light.

Salamanca Shells
Pat Mahony
Watercolor and Gouache, 15" × 20"

Mahony waited for days to capture this Spanish building in just the right lighting. With the light shining from the upper right, the seashells in the plaster create a compelling pattern of diagonal shadows across the painting.

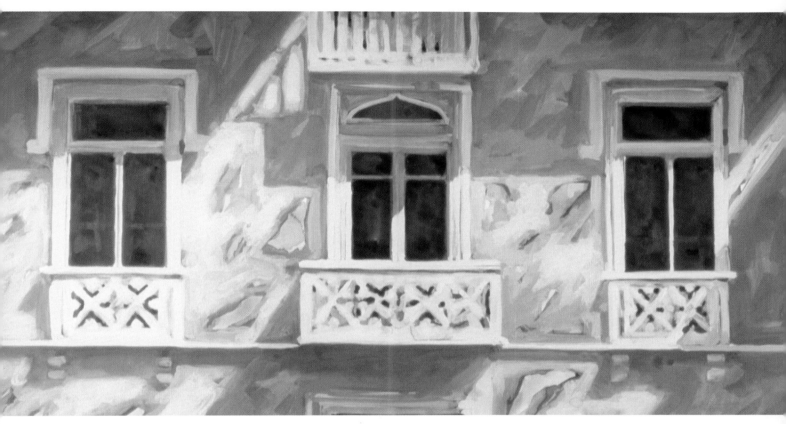

Balconies in Cascais
Pat Mahony
Watercolor and Gouache, 12″ × 23″

What keeps this from being a flat, symmetrical composition is the interesting arrangement of cast shadows. By choosing the most interesting lighting, one can turn even a simple subject into an intriguing painting.

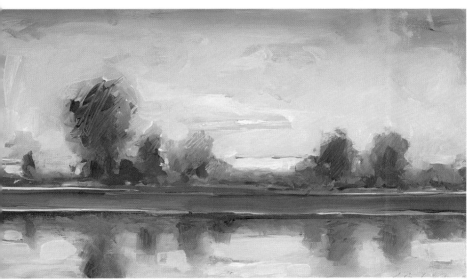

Winter River
Pat Mahony
Oil, 7″ × 11″

In this painting the values range from light gray to medium, with no extremes of contrast. It is a scene in diffused light that conveys a mood of quiet and peace.

Casting Shadows

William Wright thinks of his paintings as abstract designs of dark and light. He uses strong backlighting to create long shadows that become as much a part of the composition as the objects themselves.

Wright says, "When I gather objects for a setup, I choose pieces that have a range of forms and textures. I also select them with an eye toward how light acts on them—how it passes through glass, reflects off silver, or bounces light and color into deep shadows. In some of my paintings, I will even crop off the flower arrangement and make the painting just about the shadows."

Wright uses traditional watercolor techniques, working from light to dark. He always starts by painting the white objects first, mixing several grays predominantly from cerulean blue with touches of vermilion and raw sienna. As the painting progresses, he layers stronger and darker colors over each other to model form, saving the blacks for last.

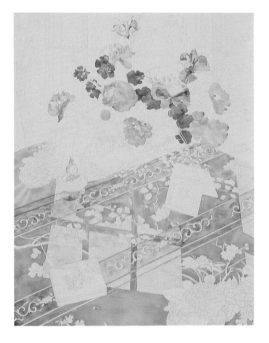

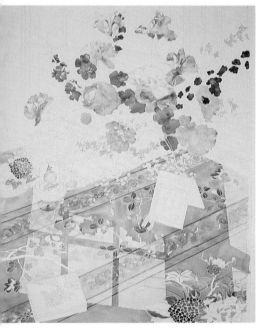

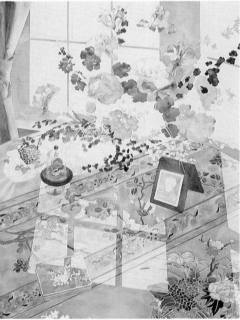

Family Set-Up
William C. Wright
Watercolor, 39" × 29"

Step 1

Wright begins with a very precise pencil drawing that lays out all the value shapes and most of the details.

Step 2

Wright begins here by painting some of the key colors in a light value, being careful to use lighter values in the areas where sunlight falls. He defines the light and shadow areas from the very beginning.

Step 3

He adds more colors and intensifies those that are already there.

Step 4

Wright works over his whole painting at once, trying to keep the entire painting moving along at the same pace.

Step 5

In the last step he adds the darkest darks. From isolated bits of color, it becomes a cohesive painting with an intriguing pattern of light and cast shadows falling from the window.

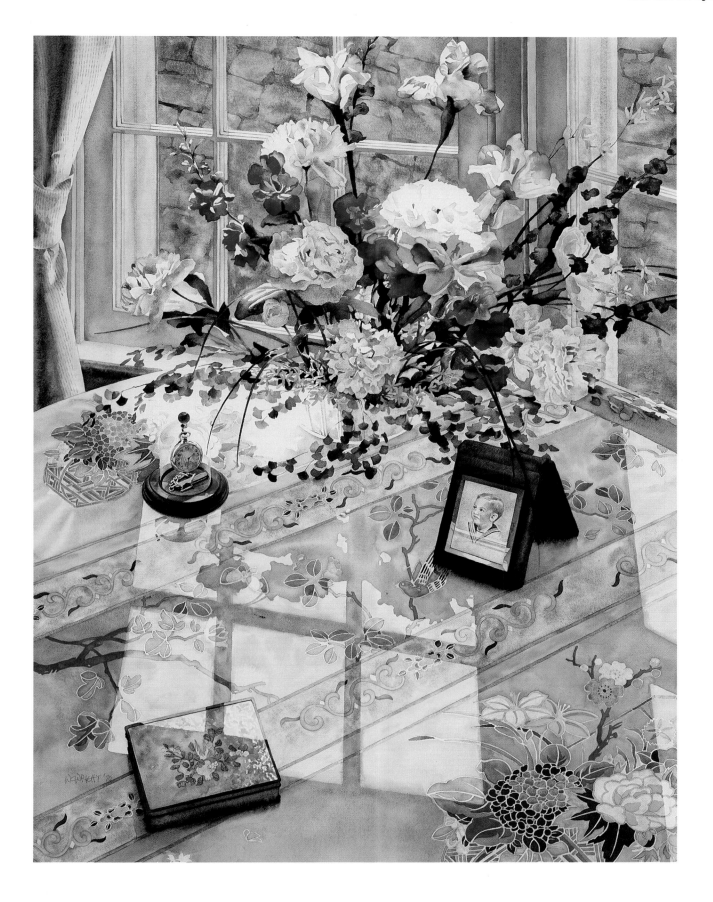

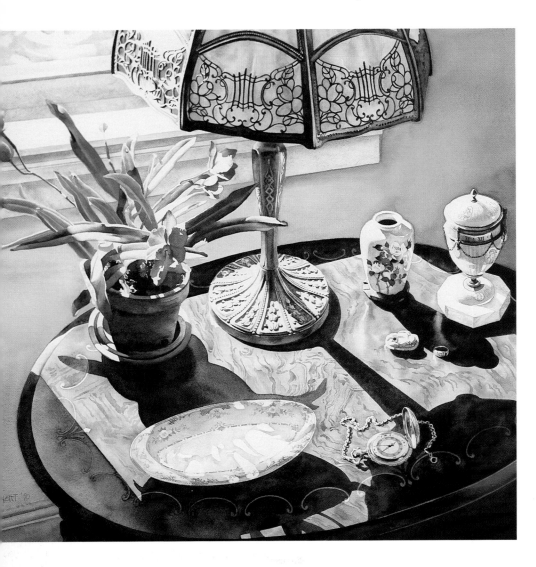

Brass Lamp With Orchid
William C. Wright
Watercolor, 20" × 20"

In this painting the light source is especially obvious, with the lightest lights in the upper left and the darkest shadows falling to the lower right. The intense value contrast adds drama to what would otherwise be a comfortable arrangement of everyday items.

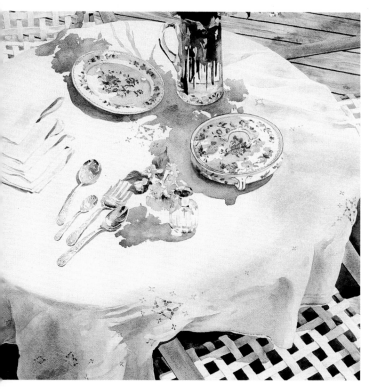

Under the Cherry Blossom
William C. Wright
Watercolor, 18″ × 18″

In this painting you can see how many colors and values can be used to show white objects. Look at the wide range of values in the tablecloth from the blue-grays of the cast shadows to the pure white of sunlit cloth.

Under the Cherry and Lilacs
William C. Wright
Watercolor, 16″ × 12″

Wright is an artist who makes maximum use of cast shadows. Look at the wonderful pattern created by the sun shining against the cut blossoms. Even without showing the flowers themselves, the painting would have a vital composition just from the shapes of the shadows.

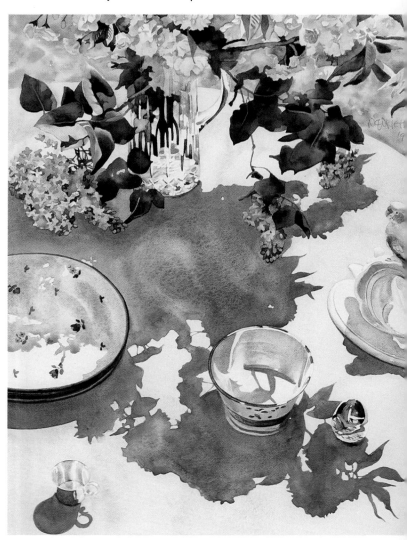

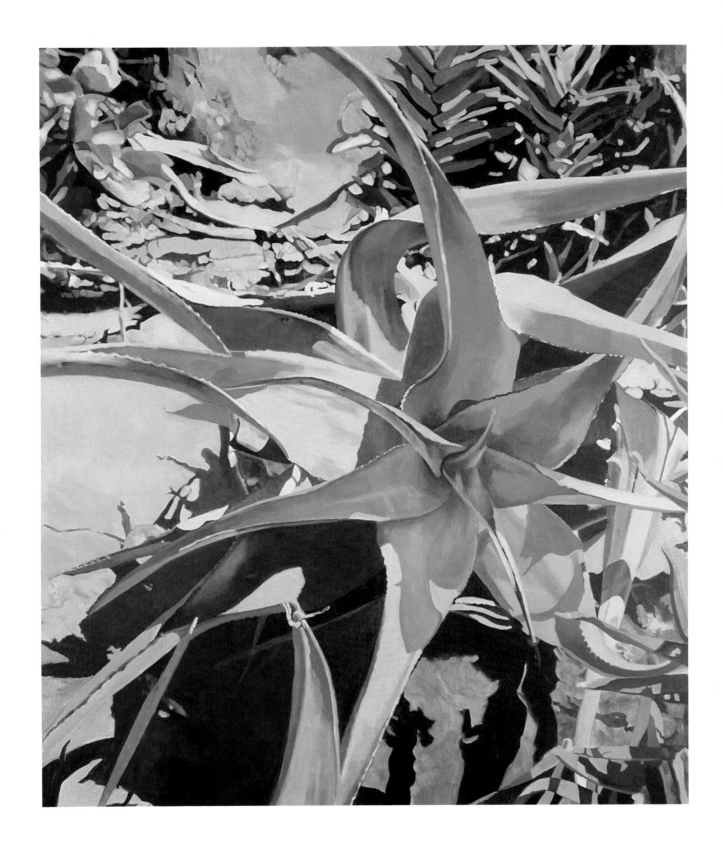

Chapter Four

Tonal Value and Form

Century Plant
Pat Berger
Acrylic, 60" × 48"

The strong contrast between the highlights and shadows distinguishes the individual leaves. Within the large leaves, the gradation of values shows how the leaves bend and curve.

What we generally look at to decide if a painted image looks real or believable is the form. The two-dimensional shapes must be accurately rendered and the three-dimensional forms must look solid. So if you want to create realistic paintings, form is the place to begin.

There are two kinds of form in painting—two-dimensional and three-dimensional—and both are made visible with tonal value.

How do you show a two-dimensional form? Either you draw an outline around it or you place it against negative space. However, if the outline is the same value as the ground or the background is the same value as the flat shape, then it's difficult, if not impossible, to distinguish the form. Even if you use different colors for the figure and ground, colors of the same tonal value will blend visually, obscuring the figure. So, if you want to emphasize a flat shape, increase the contrast between the shape and the area around it. Conversely, if you want to hide a shape, surround it with a ground of the same value.

Form in Three Dimensions

Three-dimensional form is a bit more complicated. You create the illusion that an object is round or solid by showing how the values change as light falls on the object.

Rounded Object. For a rounded object there are five value areas to portray. The brightest is the area where direct light is falling, the part of the subject that is closest to the light source. Second brightest is the area in indirect light—not as light as the first portion. Third is the darker shadow area where no direct light is falling, the section that is furthest from the light source. Fourth is reflected light in the shadowed area; this is usually seen as a lighter edge on the outside of the shadowed area. The fifth and generally darkest value is the cast shadow. This is the area around the object where no light is falling, because the object is blocking the light rays.

Objects With Flat Planes. On a shape with flat planes, the planes facing the light source will be light, with the lightest values closest to the source and the rest of the plane becoming slightly darker as it moves away from the light. Planes facing away from the light source directly will be darker. How much darker depends on how much reflected light falls on them. Those facing away from the light will be darkest.

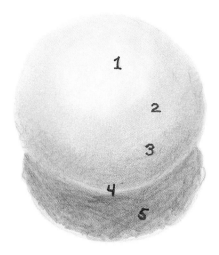

When you are modeling rounded forms, be aware of these five areas of value: 1) direct light, 2) indirect light, 3) shadow, 4) reflected light and 5) cast shadow.

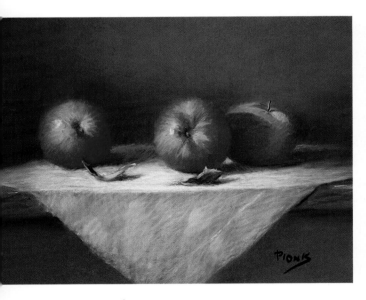

Apples
Richard Pionk
Pastel, 10″ × 12″

In order to give these apples a sense of volume, Pionk carefully modeled the values, added cast shadows where appropriate, and blended the edges of the fruit.

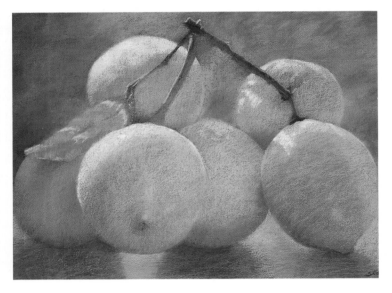

Lemons
Sally Strand
Pastel, 20″ × 30″

These lemons look real and solid because of the careful modeling of value. Pick out the value areas: direct light, indirect light, reflected light, shadow and cast shadow.

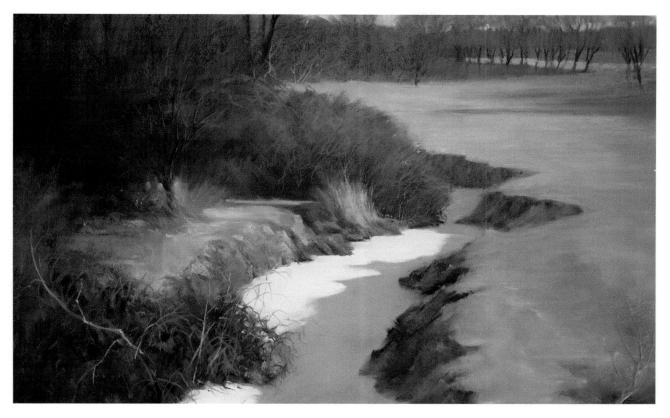

Making It Look Real

Many elements go into creating realistic form—draftsmanship, color, color temperature and, of course, value. Start your study of form by looking at the way light falls onto simple objects. Where are the lightest areas? The darkest? Do the values blend into each other or remain distinct?

Practice drawing those simple objects. Don't draw the highlights that you *think* should be there. Draw the lights and shadows that you actually *see*. Move your light source around and draw the same object with different highlights and shadows. Draw balls and eggs and simple cubes so you can learn to see and re-create the fall of light on rounded and flat surfaces. After you learn to model simple shapes, you can start to work on more complicated subjects.

Frozen Creek
Robert Frank
Pastel, 21″ × 29″

Robert Frank made the banks of this snow-covered stream appear to have a solid form by dividing the banks into planes that are in light and planes in shadow.

White Light
Stephen Scott Young
Tempera, 9″ × 12″

Value is especially important in making flat architectural shapes look solid. Here, the cast shadows reveal the shape of the overhanging gable. The pattern of ridges in the roof is also shown with value changes.

Nude Study
Richard Pionk
Pastel, 24″ × 19″

One technique for simplifying complicated forms like the human figure is to break the larger shape down into small, geometric forms, so that each part of the face and body is rendered as a cube, cone or sphere.

Shadows and Edges. Two elements that help make your forms look realistic are cast shadows and edges. Real objects cast shadows. So, if you want to make an object in a painting look real, give it a shadow. Even a flat shape painted with no modeling of values will take on a three-dimensional quality when you add a cast shadow to it.

Edges are a bit more complicated. Edges can be hard or soft, and that quality will have a definite effect on the apparent reality of an object. A shape with an outline around it or all hard edges will tend to look flat. By breaking up the outline or softening at least part of the edges, the form will have a more three-dimensional quality.

Desert Meander
Susan Shatter
Watercolor, 48¾″ × 41¼″

Notice how the modeling of these mountain forms closely resembles the modeling of forms in the figure above. Shapes are shapes whether they are very large or human size.

Exercise
Simple Shapes

Place a group of simple geometric shapes on a flat surface. They can be round balls, cubes, cones and pyramids. Light the setup with a spotlight so you have one strong light source. Now, with gray or one other color, draw or paint the still life *with no line*. Show the shapes and separation just with value.

This exercise forces you to see value shapes without outlines. The only lines that occur will be the edges where one value shape rests against another.

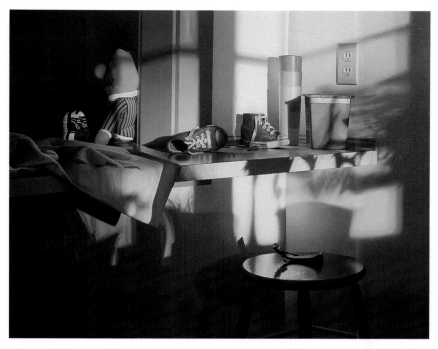

Red Sneakers
Scott Prior
Oil, 48" × 60"

For a scene to look real in a painting, the artist must model not only the main objects, but all of the details. It's in the consistent portrayal of light and shadow on all the forms of the subject that the illusion of reality is created. Notice the care with which Prior developed the values in a detail such as the electrical outlet. By looking at this one small item you can tell exactly where the light source is.

Strawberries on the Deck
William C. Wright
Watercolor, 40" × 30"

Wright's draftsmanship and placement of color are brilliant. Look at the way he shows light falling on the teacups and silverware, convincing us of three-dimensional form with careful modeling.

The Right Value

There is no one value that is always right for a bright highlight or a dark shadow. Values exist in relationship to each other. When you put two paintings next to each other, you may find that the value for the lightest light in one is as dark as the value of the shadows in the other.

In any particular painting the lights will be light and the darks will be dark in comparison to the values within the painting itself. In a high-key painting all the values will be light; in a low-key painting all the values will be dark. Even using a partial range of values, you can model forms to look three-dimensional.

When you are modeling a particular form, it can be helpful to begin by laying in part of the lightest light and the darkest dark. Then you can design the other values in relationship to those. Or you can establish the middle value and go in both directions from there. The important thing to remember is that the roundness or flatness of a particular object will be established largely by your use of values.

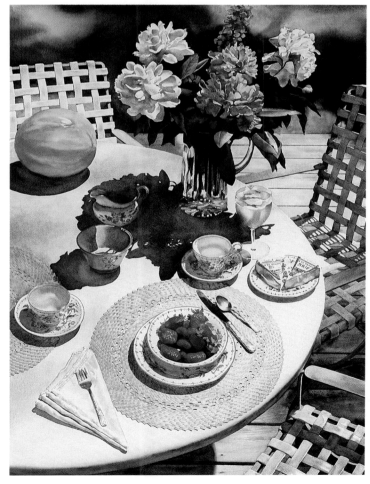

A Dramatic Reality

What makes Deborah Deichler's paintings so powerful is that they look totally real to the eye, but they jar the mind. There are incongruous elements, objects that don't make sense, strange lighting—things that make the viewer pause and try to figure out the mystery.

Deichler is brilliant at capturing three-dimensional form. The items that she puts together in a setup are always a bit strange, but we never question their reality. She creates bold, unusual lighting in each composition by carefully re-creating the light and dark values of the image.

Some people think Deichler's work looks real because of the careful rendering of detail. She says that she actually minimizes detail in her paintings. The foundation of each painting is value and draftsmanship. After the value and shape relationships are clearly defined, she adds only enough detail and texture to convince the eye that the object is really there.

She emphasizes that value is the key. She says, "Volume will appear flat without value. Even flat paper on a flat wall can be given a sense of volume by an edge of value."

Humidor With Easter Basket
Deborah Deichler
Pastel, 43" × 31"

Step 1

Deichler begins with a light charcoal sketch of all the objects' outlines. From the very beginning, she uses pastels that are as close to the final color and value as possible. She works from top to bottom because of the falling pastel dust.

The white of the teacups and rabbits represent her lightest lights, which appear even lighter because they are surrounded by dark shadowed areas. With pastel she obtains her darkest darks by mixing strokes of black with dark reds, purples, blues or greens.

Step 2

She moves down from the top to create the dark shadowed areas that frame the painting. She works loosely and sketchily, with much smearing.

Step 3

For colored areas such as the green cabinet, she develops the values with gray or grayish colors first, concentrating just on where the light and shadows are falling. Once the values are in place, she goes back and refines the color.

Step 4

Where the brightest light is falling in the painting, Deichler has carefully modeled each form. In the shadowed areas she simply suggests the forms and details, and that suggestion is enough to complete the image.

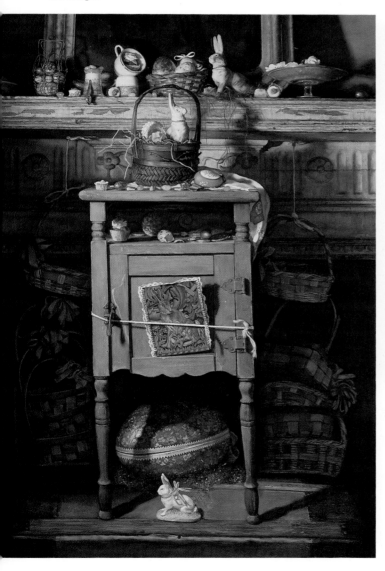

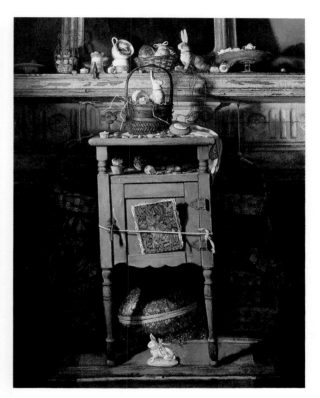

Here you can see how rigorously the artist developed all the values throughout the painting. Look especially at the range of values within the darker areas. Varying the darks makes a much more interesting painting than if the shadowed areas were all pure black.

Jacob
Deborah Deichler
Oil, 22½" × 15¼"

To create real-looking figures, carefully model the values. Look at the little boy's face to find all the gradations of light—direct light, indirect light, shadow, cast shadow and reflected light.

Susan in White Slip
Deborah Deichler
Pastel, 19″ × 25″

Before Deichler begins an oil painting of any model, she familiarizes herself with the figure in a loose pastel painting. This painting of Susan is one of those studies. Of primary concern to the artist here is the arrangement of values. Consequently, she develops the image first in black, using a lot of smudged, soft charcoal before applying local color.

Transforming Nature

"To make a painting is not just to record nature," says Eleanore Berman. "The painting has to transform nature for its own end." Because Berman is concerned with painting the spirit or essence of what she sees rather than the exact objects, her forms tend to go beyond what would appear in nature. The lights are lighter, the darks are darker, the shapes are rounder and more solid.

She says, "By using the extremes of light and dark, it creates a tension, a drama. If you put a little edge of light on a dark shape, it makes it more mysterious. That's what I'm doing with a simple thing like a hedge."

Hedge
Eleanore Berman
Oil, 24" × 24"

First, Berman determines where the dark and light values have to be in order to create the illusion of three-dimensional forms. She then marks the shapes with simple charcoal lines and, with her first strokes of color, indicates where the shadows and highlights will be. Then she gradually builds up the color values with bold strokes of oil paint, adding more and more layers of strokes until the forms appear to be solid.

Bushes
Eleanore Berman
Acrylic, 54" × 72"

Berman works in series, selecting a subject and then painting it again and again until it loses its intrigue. Within the series she alters size, color, medium, composition and lighting. What is common to these paintings of hedges is the solidity she creates for the round bushes primarily by establishing strong highlights and shadows.

Trees in the Park
Eleanore Berman
Pastel, 22¾" × 29¾"

All of the foliage in the background is painted in loose, unspecific shapes, yet there is no doubt these are three-dimensional forms, created by Berman's strong use of highlight and shadow.

Garden Path
Eleanore Berman
Oil Pastel, 22" × 30"

Berman establishes her color values by overlaying many individual strokes of pigment. Up close you can distinguish the separate strokes, but at a distance or by squinting your eyes you see the painting as a composition of solid shapes.

Fooling the Eye

In *trompe l'oeil* (fool the eye) paintings, believable form is vital; the whole style of painting is about making things look real and tangible. So, even though Barbara Dixon Drewa works with a very shallow space, she is still very concerned with the correct value of highlights and shadows.

This artist specializes in painting thin things against a flat background, such as a postcard pinned to a corkboard. The postcard doesn't cast a large shadow, but it still needs a strong shadow to make the card stand away from the background.

"I will paint pieces of Scotch tape on my paintings, but even something that thin will have a shadow. It's fun to watch people want to come up and try to pick the tape off," says Drewa.

Drewa arranges her chosen objects and then moves a spotlight around on them until she finds lighting that gives her a full range of values. She uses a bright spotlight to cast strong shadows and to affirm volume and color, explaining that value is as important as line to separate and distinguish objects.

Step 1

Drewa works on a wooden panel that has been gessoed and sanded to a glass-like surface. She begins by drawing the contours of the composition in pencil.

Step 2

The next stage is to establish the value range and basic colors. At this point Drewa is concerned with light, shadows, color and balance; details will come later.

Step 3

She adds more detail and develops form by modeling shapes that are more rounded.

Search for Significance
Barbara Dixon Drewa
(Triptych) Oil, 22½" × 16¼"

In the final stage Drewa refines values and
colors and adds the last of the details.

In her *trompe l'oeil* paintings Drewa
attempts to create such a powerful illu-
sion of reality that the viewer's eye is
fooled. One of her major tools in creating
this illusion is value, especially the cast
shadows that separate objects from the
background.

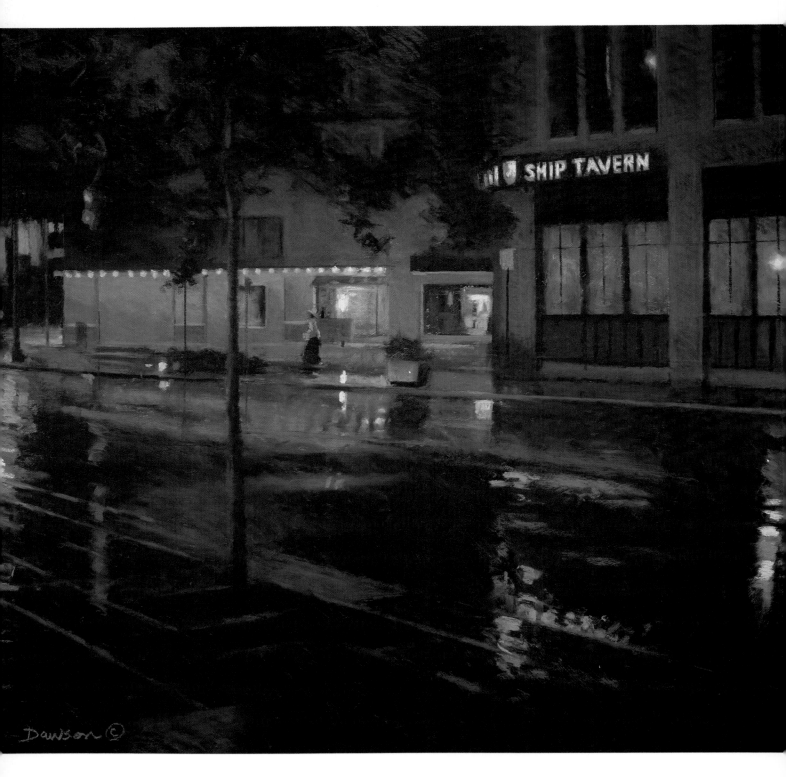

SHIP TAVERN

Dawson ©

Chapter Five

Tonal Value, Depth and Atmosphere

Ship Tavern
Doug Dawson
Pastel, 33" × 37"

Dawson likes to paint scenes at night in the rain because the wet, night streets mirror dramatic reflections of the city lights. The very light spots have even more impact because of the surrounding darks.

Depth and atmosphere are shown in a painting in five different ways. As a scene recedes in the distance, we see: 1) diminishing size, 2) overlapping shapes, 3) decreasing intensity of color, 4) less definition of line and shape and 5) decreasing value contrast. Because we are focusing on the use of value in this book, we will concentrate here primarily on decreasing value contrast.

Even though we think of air as being transparent, the atmosphere actually contains a variety of particles that deflect light and obscure our view. The particles are generally so tiny that we don't see them. We only see their effect when they accumulate over space, creating a veil-like effect that diminishes our clarity of vision. This is why the decrease in value contrast is a valuable tool for rendering distance.

London Waterfront
Everett Raymond Kinstler
Watercolor, 7" × 10"

Kinstler provides a sense of deep space
even in this very loose painting by soften-
ing all the edges in the background and
decreasing the value contrast from fore-
ground to background.

Oregon Coast
Richard Schloss
Oil, 42" × 33"

Scumbling helps create the atmosphere in
Richard Schloss's paintings. By scumbling
he softens and fuses the value forms in
the distance, making them look obscured
by particles in the atmosphere.

Values and Distance

The effect of distance on tonal val-
ues is that extreme values like
white and black appear as middle
grays. As a result of the narrowed
value range, value contrast dimin-
ishes relative to the distance from
the viewer. To show a distinction
between foreground and back-
ground, decrease the value con-
trast in the distant shapes.

For instance, in the foreground
you might paint sunlit trees that
range in value from white to black.
However, the same type of trees in
the distant background, even un-
der the same lighting conditions,
will appear in the middle values.
The sunlit background areas will
be light grays (or light colors) and
the shadowed background areas
will be darker grays (or darker col-
ors), but neither will approach the
value extremes of the foreground.

This is not to say that the back-
ground cannot be darker or lighter
than the foreground, but the range
of values shouldn't be as wide. The
background shouldn't be darker
and lighter than the foreground.

Indistinct Shapes

Another effect of distance is that value shapes will not be as distinct from one another. The lighter and darker shapes will tend to fuse together a bit, losing the sharpness of their edges. In the foreground each dark tree will stand out sharply from the light sky. In the distant background the edges of the trees and sky will blur together.

In many portraits that I have seen, the artist has drawn the figure very realistically, then filled the background with an abstract design. I find this most effective when the background design is an abstraction of the shapes that are actually there. By softening the edges and the value contrast of the forms behind the subject, the background recedes and becomes less important, but it still provides a sense of space in which the subject can sit or stand.

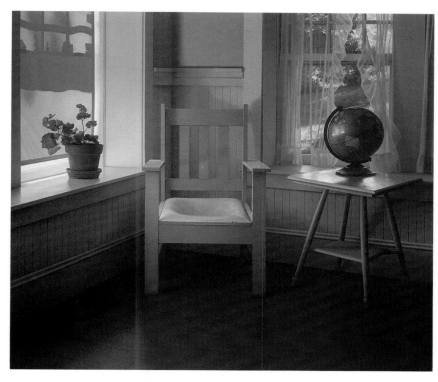

Chair, Globe, Begonia
Scott Prior
Oil, 66″ × 72″

The value contrast of objects inside this setting appears much stronger and sharper than the contrast of the view outside the window. Indoors the values go from very light to very dark. Outdoors they go only from very light to medium values.

Bus at Union Station
Doug Dawson
Pastel, 33″ × 37″

Conditions of the atmosphere, such as haze, rain or snow, obstruct our vision of objects in the distance. Dawson establishes the atmosphere in this painting by softening the edges of the value shapes, just as they are seen through the atmosphere.

Hide and Seek and Hide Again
Barbara Dixon Drewa
Oil, 18″ × 24″ × 1″

Even though Drewa paints only shallow spaces, the sense of depth is necessary for the *trompe l'oeil* effect. Here she establishes the objects' locations in space with the cast shadows. The rose, ribbon and chain are definitely in front of the corkboard because their cast shadows fall onto the board.

Cast Shadows

We have already seen how cast shadows can work to convey form. They can also show depth by defining the surface on which they are cast. For instance, if an object casts a shadow on another object, the shadow creates the location in space of both objects.

Let's say we have an apple and an orange on a tabletop. If the light source is in front of the apple and the apple casts a shadow on the orange, then we know that the orange is behind the apple. We might already know that because of the relative sizes of the objects, but the cast shadow gives their position in space more reality to the eye.

Suppose the apple is alone on the tabletop and the light is shining diagonally from the front or back. The apple will cast a shadow across the tabletop, distinguishing that horizontal plane. We know that the apple is resting on a tabletop rather than a flat, vertical shape because the shadow shows us the depth of the table.

When one object casts a shadow on another, it helps us see the spatial relationship between them.

Cast shadows help to define the surface on which they are falling.

Exercise
Making Space

Paint a simple landscape with several large objects in the foreground and several small objects in the background. Paint the foreground objects in a wide value range—white to black. Paint the background objects all in middle values.

Now paint the same composition again. This time paint the foreground objects all in middle values and the background objects with extreme value contrast. For the background objects use both very light and very dark values.

Look at both paintings and notice that the first painting has much greater spatial depth, that is, the background objects seem much further behind the foreground objects.

Katy
Deborah Deichler
Oil, 22½″ × 15¼″

We get a sense of the space in which this girl is sitting because of the way Deichler has used shadows. The cast shadows of the feet show distance between the feet and body. The cast shadows on the walls locate those walls around her. The light value of the sunlit wall outside separates that surface from the shadowed walls indoors.

Brecon Beacons, Wales
Richard Schloss
Oil, 48" × 72"

Value helps us see that these mountains
are distant in two ways. First, the value
shapes are much more defined in the fore-
ground than in the background. Second,
value contrast decreases from foreground
to background. The highlights and shad-
ows provide dramatic contrast close to the
viewer, but farther away the contrast soft-
ens to slight changes of middle values.

Demonstration ■ Robert Frank
Painting the Atmosphere

Robert Frank's soft, gentle images are awash with atmosphere. There is never any doubt about the deep space in his landscapes, partly because of his use of color, but also because of his application of value contrast.

One way that Frank establishes depth is by putting opposite values in the foreground and background. For instance, if the foreground is executed with very light values, he will tend to put dark values in the distance, or vice versa. This contrast in value creates the illusion of space between the different planes.

Frank begins with an underpainting in pastel, watercolor or oil that reflects all the dark tonal patterns in the picture. The first value masses are broad and contain the darkest and most intense colors. As he covers the underpainting with subsequent layers of pastel, he softens the intensity and refines the shapes.

Frank says, "The biggest problem students have is training the eye to look at a stick of pastel and see not just color, but also value."

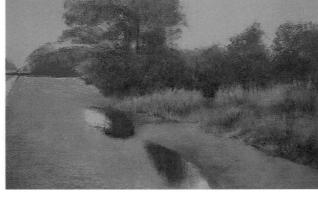

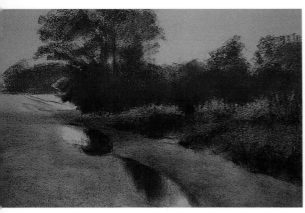

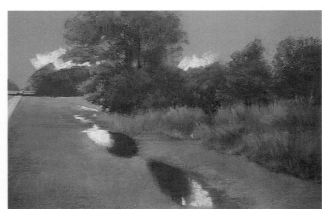

After the Rain
Robert Frank
Pastel, 12' × 17'

Step 1

On toned paper Frank sketches the composition with simple charcoal lines.

Step 2

The darkest tonal values are applied as broad masses with some paper showing through for color balance.

Step 3

Medium values are applied over darks to bring them closer to actual light conditions. Just three colors are applied in this step, all in the same value range, so they blend as a single balanced tone.

Step 4

A touch of the lightest tone is applied in the sky and water for value reference. Other tonal values are adjusted at this time. Now the full range of values is apparent.

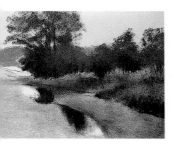 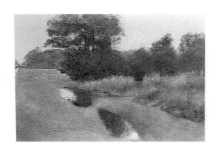 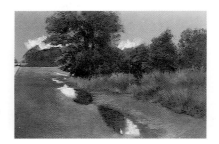 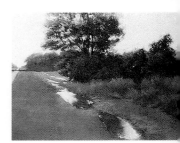

In these black-and-white photos of Robert Frank's demonstration you can clearly see the buildup of value contrast.

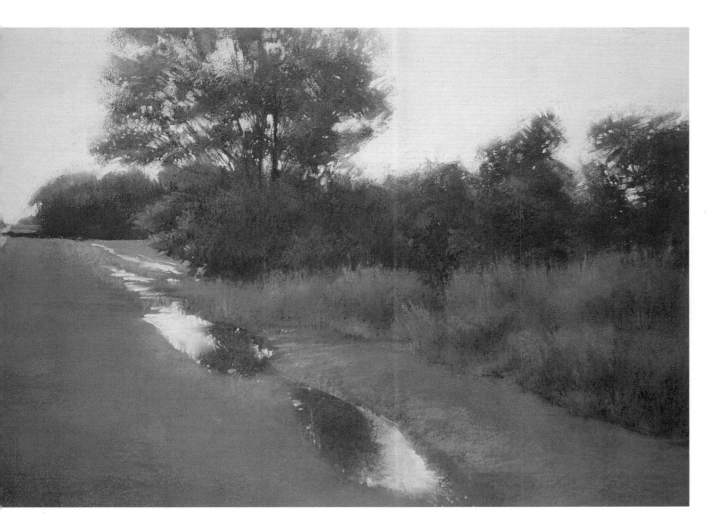

Step 5

Final modification of tonal values and color balance occur at the end. Value contrast and definition of value shapes decrease as the subject moves back into the far distance.

Santa Rosa Shoreline
Robert Frank
Pastel, 7" × 10"

Frank creates depth in this painting by using a value for the distant shape that contrasts with the foreground. Most of the painting is in light to medium values. He makes the distant hills seem separate by painting them with a dark value.

Impressionistic Tones
Robert Frank
Pastel, 7" × 10"

Frank uses a technique of building up texture in his paintings and then scumbling across the top with pastel. This method breaks up colors and values as they would appear when viewed through the atmosphere.

Country Stream
Robert Frank
Pastel, 7" × 10"

Cast shadows can be a very effective tool for establishing spatial relations of shapes in a painting. The round bush is anchored in the center of the field by its cast shadow.

Heliotrope Bouquet
Robert Frank
Pastel, 21" × 29"

Here Frank distinguishes the figure in the foreground from the shapes in the background by sharp definition of value shapes. Look at the edges of the shadows on the woman's dress. Nowhere in the distant space are any edges that fine; even the edges of the tree trunks are more blurred.

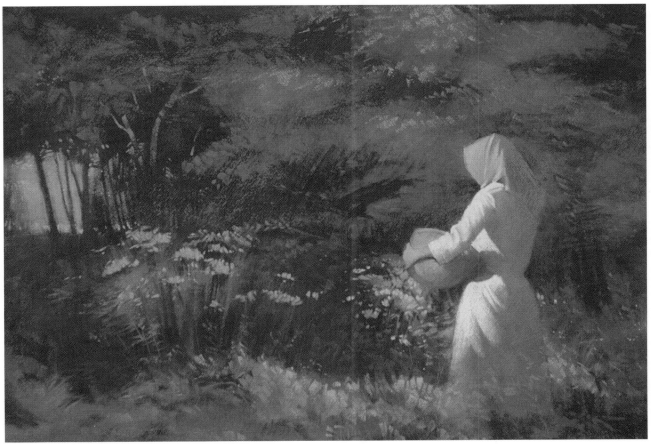

Demonstration ▪ Susan Shatter
Playing With Depth

Susan Shatter deliberately minimizes the sense of spatial depth in her paintings. She explains, "By eliminating the horizon and pushing the scene into flatter interacting planes, rather than the traditional language of foreground and distance, I am able to depict a space which is vast but visually up close. Far is near, near is far. This spatial dislocation conveys the feeling that the world can be a capricious, menacing and untameable place."

Shatter uses diminishing size and overlapping shapes to retain the look of realism in her landscapes. However, she flattens out space by maintaining the same intensity of color and contrast of values throughout the compositions. Look at the black-and-white photo on the next page—you can see that the lights and darks at the top and the bottom of the composition are equal.

She begins her painting process by traveling to geological sites that reveal the enormous forces that create land formations, without the overlay of vegetation. She often spends days looking for the most dramatic views and spectacular light. When she finds a subject, she does quick watercolor studies on location. Then she photographs the scene when the light is most exciting. ·

Back in the studio Shatter lays in large color washes to tie the lights together. In oil she paints areas in a wet-on-wet painterly way. In watercolor she layers washes of color until she gets the darks dark enough and they resonate with the lights.

Shatter says, "I never know how a painting will come out—otherwise I wouldn't do it. I like the surprise."

Desert Dawn
Susan Shatter
Pastel, 33" × 46½"

Step 1

In the first step of her watercolor, Shatter establishes the lightest lights, the darkest darks, and the placement of shadows.

Step 2

Gradually, Shatter builds up values with successive washes of color.

Step 3

In this painting Shatter gives some sense of receding space by making the shapes in the distance smaller and less detailed. However, by not greatly reducing the value contrast or the sharpness of value shapes in the background, she minimizes the depth and gives the composition a sense of flatness.

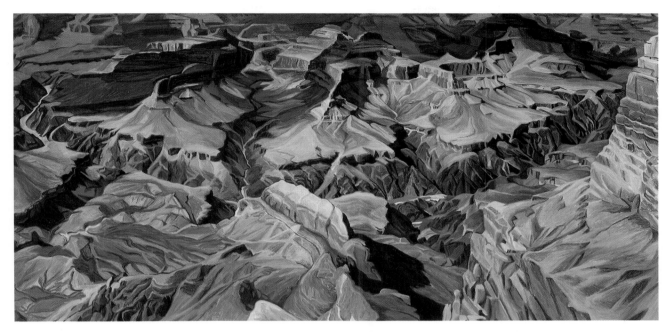

Pima Point
Susan Shatter
Oil, 45" × 91"

Shatter is more concerned with the strength of the geological forms, the pattern of lights and darks, and the rhythm of the color and shapes than with a naturalistic portrayal of depth and atmosphere. We know that this scene recedes in space because of the rendering, but the overall color and value contrast make it look like a flat image.

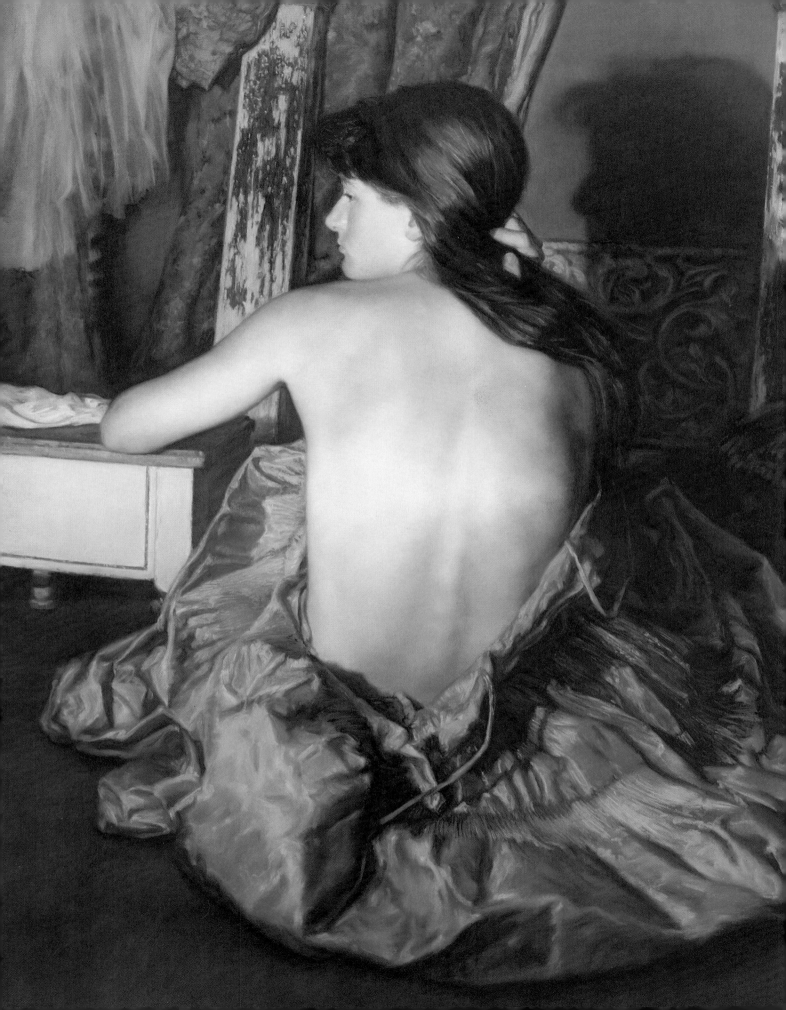

Chapter Six

Tonal Value and Mood

We have all seen paintings in which the mood creates our first impression of the piece—it is such a happy or mysterious or ominous image. What creates that mood?

One factor, of course, is subject matter. Paintings of children and flowers are usually happy. However, that isn't always the case. Both Deborah Deichler and Scott Prior paint children in scenes that are thought provoking.

Color also contributes to mood, but colors do not have inherent moods. Blue can be used in an ominous storm scene and in a cheerful still life. Even grays, which we tend to think of as somber colors, can be bright and happy.

The third factor is tonal value. How light or dark is a painting and how much value contrast does it contain? These elements will *always* affect the mood. So the painter who wants to create a special mood in a piece thinks first about value.

Light and Dark

The lightness or darkness of a painting contributes greatly to mood. A very dark painting will always convey emotion. It might be fear, sadness or mystery, but it will always be a heavy or "dark" feeling. A light painting will be happier, more friendly.

Many artists plan the value range before they begin painting to create a certain mood. For a light, happy painting, they will select values between white and middle tones. For a heavier mood, they might choose only middle to dark values. For a calm painting, they will stick to the middle tones.

Compare two of Barbara Kastner's landscapes. *View Next Door, Autumn* is bright and cheerful.

Most of the painting is light yellows and greens with only a few touches of darker values. In contrast, *The Other Side of the Lake* is dark and mysterious. The composition consists mainly of medium-dark blue shapes with just a few bright highlights. Same artist, similar subjects—but the moods are completely different because of the value range.

View Next Door, Autumn
Barbara Kastner
Casein and Acrylic, 22″ × 30″

The Other Side of the Lake
Barbara Kastner
Casein and Acrylic, 39″ × 45″

These two landscapes by Kastner show the effect of overall value on mood. In one landscape the values are all high-key, light to medium. The light painting feels warm, friendly and open. The other is a dark painting. Its feeling is quieter, closed down, a bit mysterious.

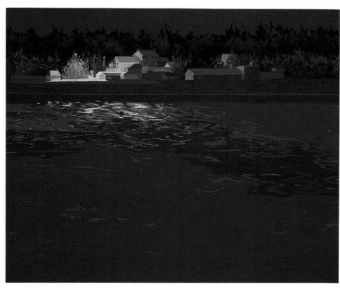

Exercise
Light and Dark Moods

Paint a small, simple landscape using colors that are only in the light value range. Nothing should be darker than a medium value.

When that painting is done, use exactly the same subject, the same composition, the same size and the same medium to paint another landscape with colors in the dark range. Your lightest lights in this painting will be medium tones.

Now compare the mood or emotional impact of the light painting and the dark painting.

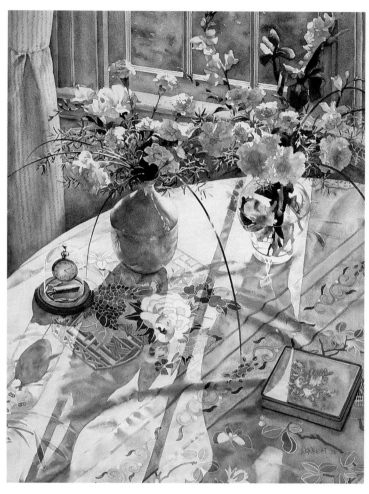

Shadows and Mood

One of the greatest tools you have for developing mood is shadow. Are there shadows in the composition? Where do they fall? How big are they? And how dark are they? These are four questions that will have a big effect on the emotion of your painting.

A scene with no shadows or very light shadows will tend to appear happy and peaceful. A scene that is mostly in shadow will tend to be mysterious. Dark shadows add even more drama and mystery. If shadows appear to be encroaching on the main figures or objects, the painting will appear ominous.

Many artists add strong cast shadows to create more interesting divisions of space in compositions. However, it's important to be aware of the emotional effect these shadows have as well.

Carnations in Winter
William C. Wright
Watercolor, 28″ × 21″

Chocolate Brunch
William C. Wright
Watercolor, 39″ × 29″

Both of these paintings are of still lifes in sunlight. Each one is an arrangement of colorful, domestic objects on a tabletop. The main difference between the two is the value of the shadows. In *Chocolate Brunch* the shadows are comparatively dark, and those dark shapes against the very light areas of the painting cause a dramatic weight. In the other painting, most of the shadows are in the light range, and the feeling of the image is light and airy.

Exercise
Dark Shadows

Paint or draw a simple still life. Carefully render each object, but don't include any shadows.

Repeat the still life, but this time add shadows. The shadows should all be in the light to medium range. Don't include any dark shadows.

Repeat the still life again, this time making all the shadows very dark.

Compare the three compositions. Notice that the painting with dark shadows is more dramatic than the others.

Value Contrast

A factor that is not as readily recognized for its effect on mood is value contrast. A painting with a narrow range of values will appear still and peaceful. Even if all the values are relatively dark, the painting will still have a calmness to it.

If, however, the value range is wide, the composition will appear livelier. The variety of light, medium and dark shapes all in the same image stimulates the eye.

Maximum drama in a composition is achieved by placing very light shapes next to very dark shapes. This is why bright highlights placed next to dark shadows have such visual punch.

When you want to create a focal point in the most dramatic way, place a spot of your lightest light and surround it with your darkest dark. It will automatically draw the eye. To establish tension in the painting, create several focal points with value contrast. The visual tension will contribute to tension in the mood of the painting.

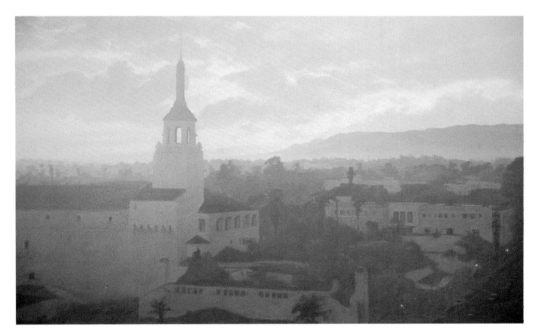

Arlington Theater at Sunset
Richard Schloss
Oil, 26" × 42"

Two value factors help contribute to the warm, gentle feel of this painting by Schloss: The values are all in the middle range so there is no jarring contrast, and the value shapes all blend together with no sharp edges to separate them.

With Child
Stephen Scott Young
Watercolor, 13½" × 14½"

This would be an easy, relaxed scene with no drama—except for the intense shadows on the woman's face. The unexpected contrast of those values gives the painting an added depth of emotion.

Sideboard
Deborah Deichler
Pastel, 15¼″ × 30½″

Deichler uses a spotlight to create omi-
nous-looking shadows in her paintings.
Even simple objects become dramatic in
her extreme patterns of dark against light.

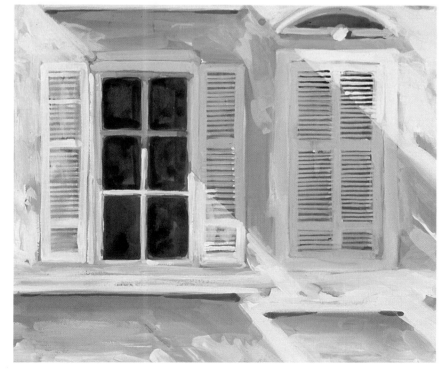

Nice
Pat Mahony
Watercolor and Gouache, 8¼″ × 9″

Cast shadows can often seem ominous or
mysterious. Here the dark window shape
provides mystery, but the shadows in a
soft middle value are simply interesting
shapes.

Painting Emotion

Most people choose not to go outside at night in the rain, especially for painting, but that is Doug Dawson's favorite time. As soon as the rain begins, he grabs his jacket and camera and heads out to the city streets.

It's not the architecture that he wants to capture, but the mood of the night—the mystery and loneliness, the despair of vague figures huddled under streetlamps, even automobile lights flickering through falling snow or rain.

Dawson says there are two aspects to painting: 1) successfully imitating what you see and 2) communicating emotion and feeling. While he is very good at the first, it is really the second that motivates him to paint. For him "painting is an interpretive act rather than imitative."

Dawson's main tool for conveying emotion is value, which he says does more to manipulate emotion or feeling than any other property of color. He says, "We associate value with emotion. We generally divide emotions into dark and light feelings even when we are not thinking of paintings. Most successful paintings fall into these categories—dark paintings with light accents, light with dark, and middle value paintings where the excitement comes from the arrangement of shapes."

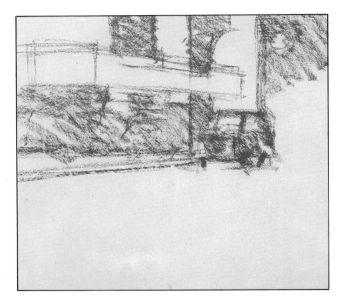

London Theater
Doug Dawson
Pastel, 20″ × 22″

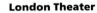

Step 1

Dawson begins his paintings by dividing the composition into value shapes. Here he places the dark shapes. His pastels are painted on Masonite primed with gesso and ground pumice. The rough tooth of this surface allows the heavy strokes that give Dawson's paintings their expressiveness.

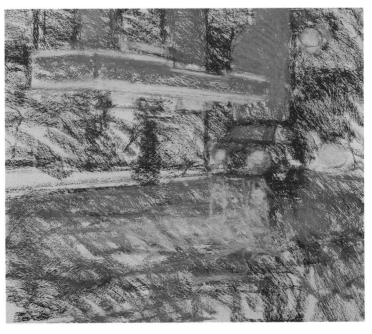

Step 2

With a few sticks of pastel he lays in the rest of the value shapes. He uses the light gold for the lightest values and several middle value colors for the middle shapes.

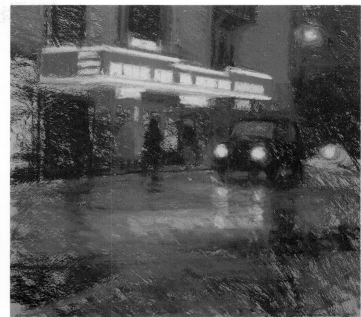

Step 3

Dawson gradually breaks down the large shapes into smaller shapes.

Step 4

He continues to add smaller shapes and to refine the shapes and values he has already placed.

Step 5

Dawson solidifies areas of color value and adds final details. The emotional impact of the scene is established by the contrast of bright lights against nighttime darks.

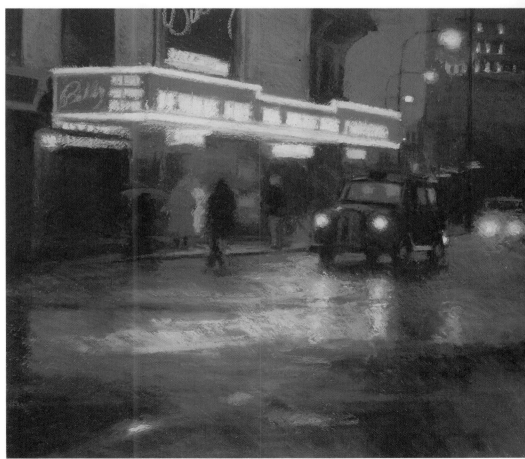

The Moods of Light

"I look for the effects of light and these are as much the subject as any of the objects I paint," says Scott Prior. "There is a lot of contemplation of a scene before I begin to paint, maybe years. I might begin with noticing the way the light comes in through a window at a certain time of day at a certain time of year.

"Sometimes an object accidentally finds itself in a particular light. It's not just the light hitting the object. I also look for reflections and light passing through things like glass, plastic or window shades."

What Prior does with this light is use it to give a dramatic, thought-provoking mood to a familiar, domestic scene. Laundry on a clothesline, children's toys, a toddler asleep—these comfortable subjects have a new, dramatic impact in the unexpected light in which Prior sets them.

He explains, "A drama is created when there is a painting or area of a painting that is dark, and one small area catches light. The colors are brighter and stronger where they are surrounded by the dark. Fleeting light is often the most poignant. I am trying to capture effects that are transitory, effects that may last for only a few seconds. There is something about a sunrise or sunset that will make people stop and look—would we be interested if the sunset lasted all day?"

Towels and Sunlight
Scott Prior
Oil, 24" × 24"

Photo study

Prior shoots photos of his subjects to capture transitory moments of light, but he does not feel bound by the color or values of the photograph.

Pencil study

Before he begins a painting, he lays out the composition in a small, but very refined pencil drawing. Values are crucial in Prior's work because he creates the mood with his dramatic lights and shadows.

Scott Prior 1991

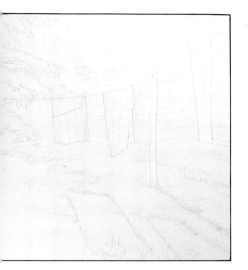 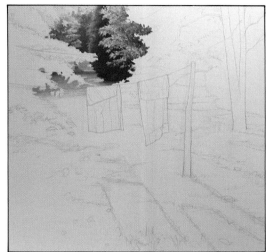 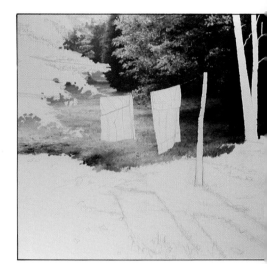

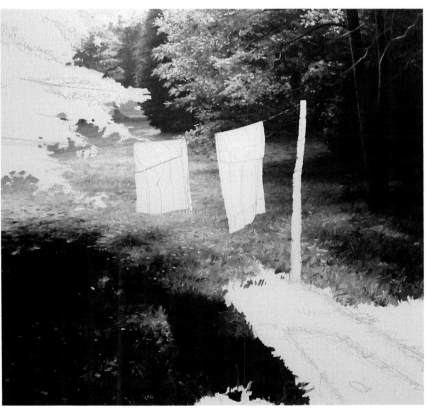

Step 1

Prior begins by laying out the composition with a simple drawing on the canvas to indicate the outlines of the piece.

Step 2

He works with oil paint in a very direct manner, with little underpainting or glazing.

Step 3

He paints one section at a time, generally moving from top to bottom of the composition. From the beginning strokes he is working for finished color and value.

Step 4

Prior often takes months to complete a canvas, so maintaining color unity takes a great deal of planning and concentration. To achieve this, he uses a limited palette of only six colors, plus white and black.

Step 5

Prior says that photos are valuable for capturing what is momentary. But he warns that there are dangers in working only from photographs. In sunlit scenes the subtleties are lost in the highlights and shadows. He prefers working from the actual scene along with the photo.

Step 6

You can see how Prior enriched the color and value in the finished painting beyond what is seen in the photo reference.

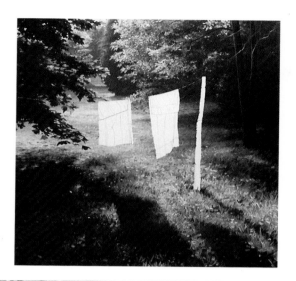

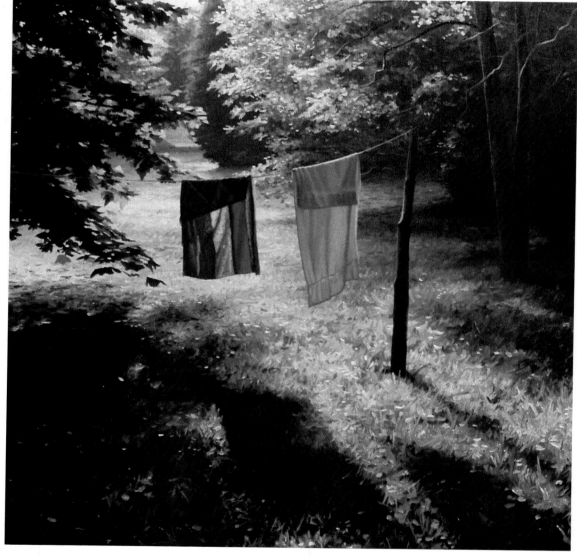

Ezra Asleep
Scott Prior
Oil, 66″ × 54″

The usual way to paint a child asleep is with colors and values that create a soft, sweet image. Prior's paintings of his children have a much more potent emotional effect because of dramatic backlighting and a great reliance on the middle to dark values.

The Expressive Gesture

Jody dePew McLeane's paintings are about gesture, not just the movement of the figure, but the mood of the gesture as well. Her figures are always acting or interacting and the viewer is provoked to ask, Why are they turning or looking or leaning that way?

McLeane works from scenes that she sees, although sometimes she changes the values to strengthen the gesture. She says, "So many things I see are flat, nondimensional. You can make them more exciting by increasing the contrast."

She looks for strong contrast and puts the focal points in isolated areas of light so they punch out at the viewer.

"I don't buy flesh colors," McLeane says. "I use a lot of greens and reds and taupe-colored browns. It's more emotional to have a big green swath on the face rather than the expected blue-purple shadow.

"I let myself play with lights and darks and colors. If it works, I'm excited and if it doesn't, I start again."

Two Girls in a Dining Room
Jody dePew McLeane
Pastel, 16" × 20"

With her concern for the drama of a scene rather than the realism, McLeane will take great liberties with the color and value. Look at the two faces in which the values are distorted to create a visual and emotional impact.

Coffee in the Deli

Jody dePew McLeane
Pastel, 32" × 40"

Step 1

McLeane begins with the gesture of her figure and a gestural sketch of the total scene. She paints on toned paper, which works as a middle value, while she establishes her lights and darks. Notice the ochre and purple in the face and hair; McLeane will manipulate color and value to attain the emotional impact she wants in an image.

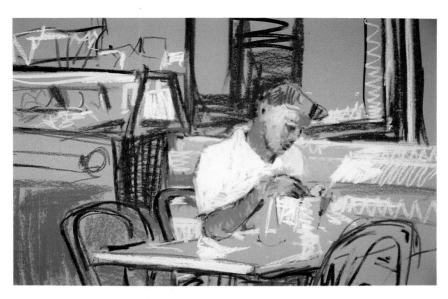

Step 2

She fills in and solidifies more of the value areas, concentrating first on the lights.

Step 3

In the final phase, McLeane places the darks and refines all the shapes and details. Compare the first step and the last step; notice how the emotion of the painting gets more intense as McLeane adds darker values.

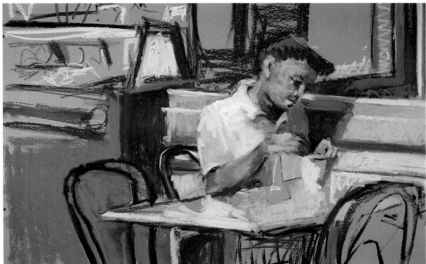

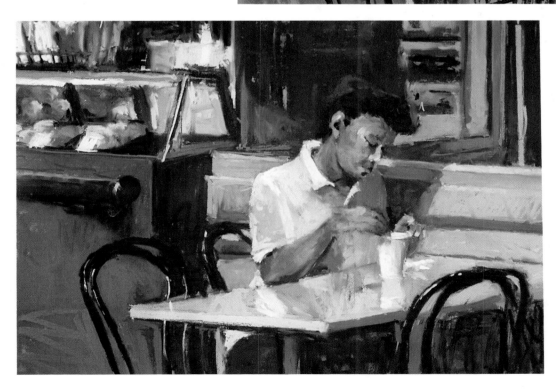

The Bass Player/Guitar Player
Jody dePew McLeane
Pastel, 26" × 20"

McLeane uses a strong contrast of light and dark to add drama to a scene. Look at the theatrical fall of light on the faces in this painting.

Bar Conversation
Jody dePew McLeane
Pastel, 24" × 28"

McLeane creates expression in her paintings with bold strokes and strong contrasts. She makes the gestures more obvious with value contrast. Notice how the black shadow on the bartender butts up against the light yellow background, and the white shirt in the foreground is a definite shape against the darker gray shirt.

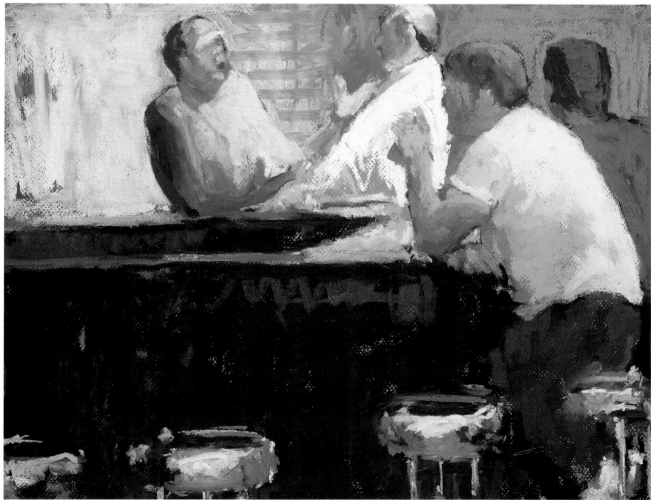

Winter Light
Scott Prior
Oil, 48″ × 42″

Prior is able to make a ball and a baby's toy look mysterious, even a bit ominous, with his placement of light and shadow. There is something stark and forbidding about the geometric arrangement of darks against lights.

Nanny and Scott
Scott Prior
Oil, 72″ × 84″

Prior achieves drama and mystery in simple domestic scenes with his unusual use of light and shadow. Here the figures are in shadow and the background through the windows is given full sunlight.

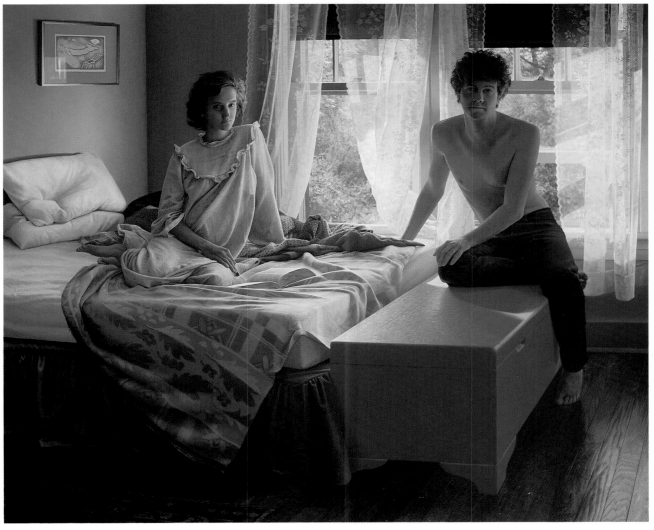

Chapter Seven

Tonal Value and Composition

Winter/Summer
Sandra Kaplan
Oil, 104″ × 48″,
2 panels

This composition is actually an arrangement of shapes of various textures. At the top is the rectangle with the pattern of outdoor trees and shadows. The center shape is the intricate design of tropical plants. The bottom is the geometric pattern of stairs and railing.

Composition refers to the arrangement or design of the shapes within a painting. The design is the foundation of the painting. Tonal value is your main tool in making these shapes work the way you want them to.

The two elements that work together to make up a good composition are *balance* and *movement*. Balance means that when you divide a painting in half—horizontally, vertically or diagonally—each side will have equal weight. That is, both sides will contain the same amount of visual interest.

The most perfectly balanced composition is symmetrical, a design where the sides mirror each other. However, a symmetrical composition may be static and boring to the eye. What makes the composition interesting is movement, those elements in the composition that make the eye move from one area of the painting to another.

Since maximum stability occurs when opposing shapes are exactly the same in size, shape and value, you can increase movement by altering any one of these. If you make one shape bigger than another, your eye will go first to the bigger shape, then it will be drawn to the smaller shape, and back again to the bigger shape. That is what is meant by movement.

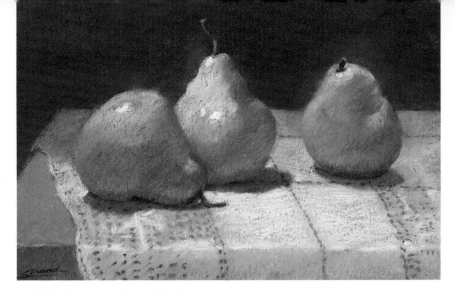

Focal Point

Three elements of composition in which tonal value can assert its influence are focal point, tension and rhythm.

There is generally one main shape in a painting, one area that has the greatest visual interest. This is the focal point because it draws the eye to it first. The focal point is often created with value—one dark shape in a light painting or one light shape in a dark painting will have enough drama to attract the eye. The focal point can also be determined by size or degree of interest.

Tension

Tension in a composition is just what it sounds like, a sense of discomfort, something being pushed or pulled, a slight lack of balance. A certain amount of tension within a painting is a good thing. It adds drama, it draws the eye and keeps the viewer looking. However, too much tension will make looking at the painting uncomfortable and force the eye away.

Tension can be achieved with the division of values or the placement of an important shape. Having more darks than lights or more lights than darks will create tension. Distributing the lights and darks unevenly, or in a disturbing pattern, will also create tension.

Rhythm

Rhythm in a painting is generally achieved through repetition. Repeating shapes, strokes or values throughout the composition will add harmony to the image. However, if the entire painting is composed of exactly the same strokes or other repeated elements, the composition can appear monotonous.

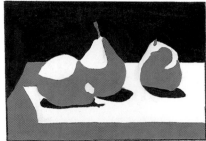

Pears
Sally Strand
Pastel, 9" × 12½"

This design is composed of three values—dark in the background and shadows, light in the tablecloth, and medium for the pears and table. The dark shadows keep the dark background from overpowering the lighter bottom half of the painting.

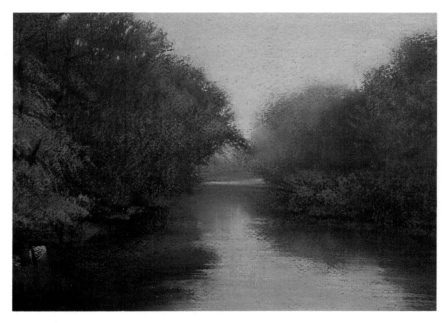

Shades of Monet
Robert Frank
Pastel, 7" × 10"

This is a perfectly balanced composition. No matter how you divide the format, you still have equal weight in both halves. Frank kept it from being totally static by painting shapes that are similar, but not exactly symmetrical.

Christmas Dinner
Pat Berger
Acrylic, 40" × 48"

Even though the subject of this painting is several figures, the composition comprises the division of shadows and sunlit areas. Even without the figures the values give an interesting abstract pattern.

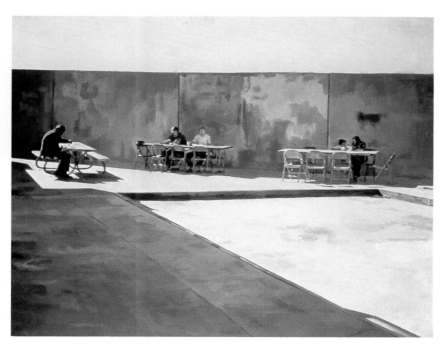

Hannover—Country Lane
Pat Berger
Oil Sticks, 22" × 30"

When you squint your eyes, you can see the three dark shapes that comprise this composition. Notice that the three shapes form a triangle, thus giving greater stability to the design.

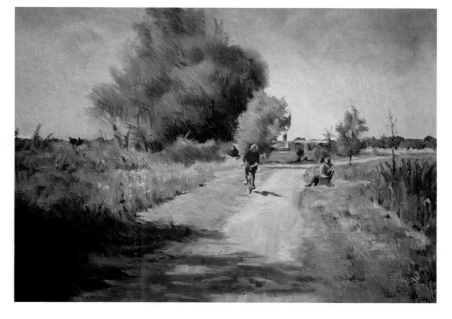

Value as Weight

Value shows up in a composition as weight. The darker shapes will seem heavier and can overpower lighter shapes unless they are balanced within the design. Extreme values will generally have more visual weight than middle tones, so you can often balance a large gray shape with a smaller black or white shape. The most harmonious patterns will use a full range of values; the most dramatic will juxtapose extreme lights and darks without grays to soften the contrast.

The apparent weight of a value in a composition often depends on the value that surrounds it. A white against light grays will not be particularly noticed, but a white surrounded by darks will immediately draw the eye to it.

Good and Bad Composition

There is no one best composition; the important thing is that the amount of tension and the movement of the eye around a painting be consistent with the subject and intended mood. However, there is *bad* composition. A bad composition is any design that detracts from the intent of the artist. This could be either a totally stable composition, so balanced that it is uninteresting, or a painting with so much tension or imbalance that it forces the eye away.

To judge a composition, look at the painting just in terms of abstract shapes. Find the shape that is the focal point. This is often the darkest or lightest one. Notice the shapes that surround the focal point. Next, find the shapes that surround these shapes, until the whole composition appears like a puzzle of abstracted shapes.

Look at the composition upside down, sideways or in a mirror. Ignore the subject matter and look to see if the pure shapes work together in a harmonious, interesting pattern.

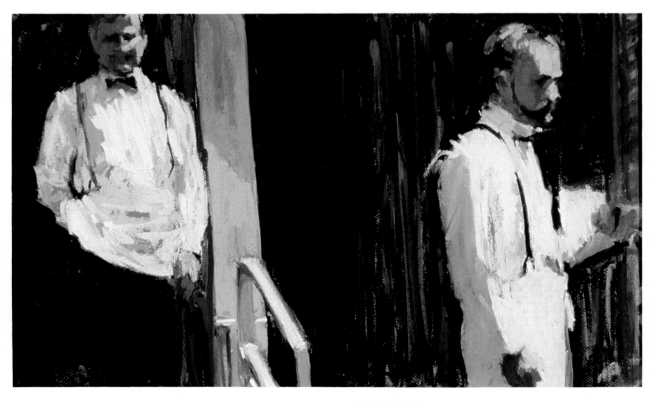

Two Waiters in the Sun
Jody dePew McLeane
Pastel, 16" × 26"

This composition consists of two separate white shapes surrounded by dark. McLeane often uses the composition to enhance the mood or meaning of her paintings. Separating these figures greatly adds to the drama of the image.

Farm Pond
Robert Frank
Pastel, 7″ × 10″

Cast shadows can be a vital part of a composition. Here, cast shadows create a pattern of diagonal shapes in the center of the painting; those repetitive shapes add movement and rhythm to the design.

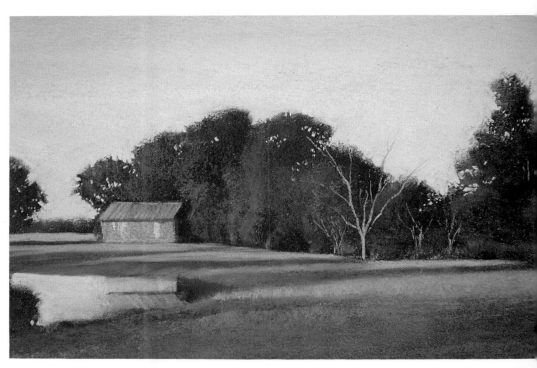

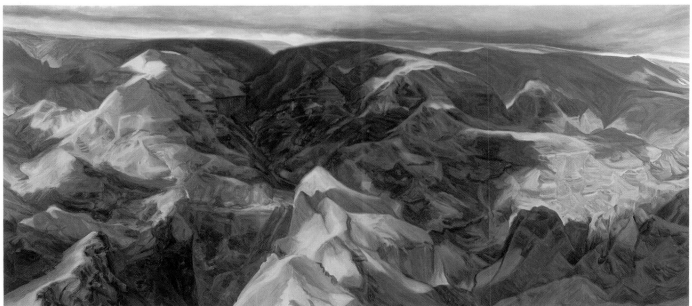

Winged Shadow, Wainea Canyon, Kauai
Susan Shatter
Oil, 52″ × 114″

In color, this large painting looks like a very complex composition, but when you look at it in black and white, you can actually see that it is a simple arrangement of light and dark shapes.

Composing With Space

"I am interested in large, strong shapes and spaces," says Barbara Kastner. She often eliminates all but the most essential objects from her subject in order to create the most striking composition. She often works with a large expanse of dark negative space setting off a small, light-colored subject.

Kastner says, "Everything in my paintings is very familiar. I like to jolt the viewer by putting the ordinary in an unexpected circumstance, making them look at something in a way they have never seen it before. I try to set up a psychological tension within the painting."

Kastner develops her composition as she goes along. She works with opaque water media so that she will have the freedom to change her work, adding and deleting objects several times as she develops the finished image. Her beginning composition is often more complex than the final painting. She likes to pare the composition down to the bare bones of what she wants to say. This loose, creative process allows her to add and change until the painting makes a powerful statement.

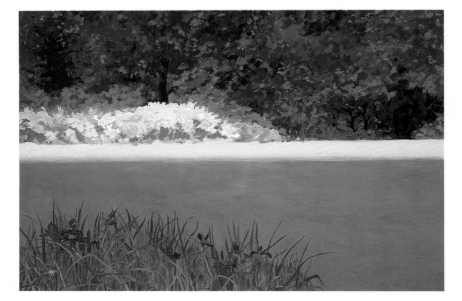

Backyard With Iris
Barbara Kastner
Casein and Acrylic, 29¼" × 41¼"

The power of this composition comes from the contrasts. First is the contrast of value, the horizontal stripe of light value across the center of a medium-dark image. Second is the solid color of the center in contrast with the texture of the foliage.

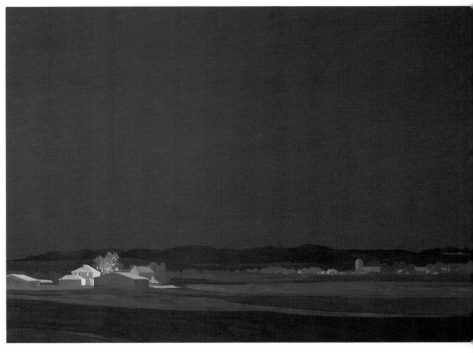

Vigil #5
Barbara Kastner
Casein and Acrylic, 29¼" × 41¼"

In her night scenes Kastner deliberately makes most of the painting dark to provide a dramatic contrast for the small, light areas. She likes the tension that is created by the imbalance of a large, dark area and a small, light area and feels that it adds to the mystery and drama of the scene.

Take-Out
Barbara Kastner
Casein and Acrylic, 18″ × 24″

Kastner decided when this painting was nearly finished that the top of the painting was too dark (at the time it was dark blue), so she lightened the sky. Now the top and bottom are more balanced.

View Next Door, Summer
Barbara Kastner
Casein and Acrylic, 22″ × 30″

This composition is primarily made up of three horizontal stripes—the textured section of flowers at the bottom, the solid values in the center, and the textured foliage in the top. To keep the painting from being too static, Kastner has broken up the horizontal design with vertical tree shapes. (See page 88 for the companion work, *View Next Door, Autumn*.)

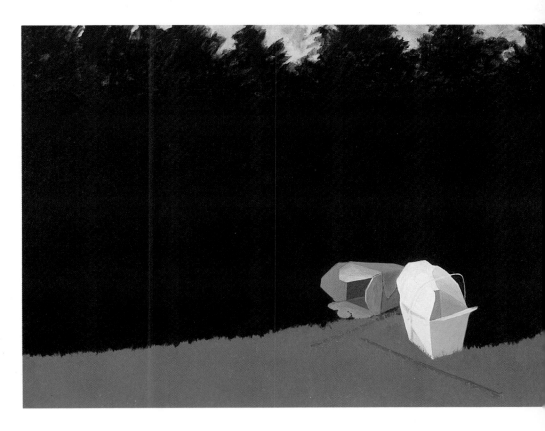

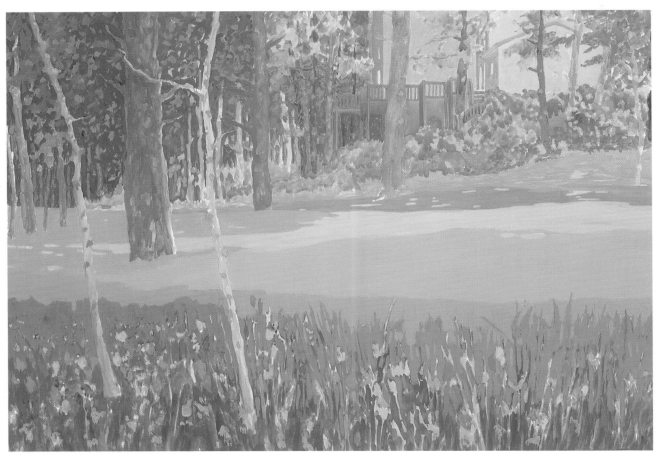

Designing With Black

Kendahl Jan Jubb specializes in intricate, decorative images built of numerous textured shapes. She works on balancing the textures so the composition will hang together and not break apart into individual patterns. Values are crucial. She says that if the values are off, the painting will pull itself apart.

In developing her composition, she starts with the focal point. She puts in the pivotal shape and then develops the patterns that lead away from or to that form, using the arrangement of textures to provide movement.

Jubb is one of the few painters who is unafraid of black. Although she does treat the powerful, dark value with respect, she relies on it heavily to provide a weighty contrast to her intricate patterns. She sees the negative space as an integral part of her compositions, and by using black she is able to give the negative space more importance.

"I see value as drama," she says. "I like a lot of contrast and I use black because of the dramatic value that it has. Black makes the other colors more brilliant. Also I like black because it gives the negative space more depth, more weight."

July Arrangement With Peaches
Kendahl Jan Jubb
Watercolor, 25" × 22"

Exercise
Negative Space

Arrange three or four objects into a simple still life. Draw the outlines of each of the objects and fill all of the space outside the objects with black. Do not draw anything inside the objects.

When the negative space and the objects are divided into black and white, you can clearly see how the objects fit into the format. Are the objects balanced in the composition? If they are not balanced, do they need to be moved or could you add another object somewhere else in the composition to balance them?

Step 1

Jubb begins with a careful drawing of all of the shapes that will go into the painting, including even the tiny shapes that will be the pattern in the flowers. She starts painting by completing all of the pink petals.

Step 2

Working color by color, she adds all of the blue, most of the yellow and green, and some of the red.

Step 3

Now with all of the colors placed in the subject, she begins to add black to the negative space. The flowers have a light, airy feel with white around them; this will change as she fills in the negative space.

Step 4

Colors get more intense and the flowers look more dramatic as they are surrounded by black. By comparing Step 3 to this final image, you can see how much more powerful the composition is with black rather than white in the background. An interesting compositional element is the repeated shape of the single peach and the group of peaches. Repeating shapes or patterns, especially in a design with many shapes or textures, adds harmony to the total structure.

Spring Birds
Kendahl Jan Jubb
Watercolor, 38" × 29"

It is hard to keep such an intricate arrangement of textures as this from seeming chaotic. Jubb manages to bring harmony to this composition by repeating patterns and by setting textures against solid areas.

Reef Aquarium
Kendahl Jan Jubb
Watercolor, 30" × 42"

One of the most interesting textures Jubb uses can be seen in the brightly colored underwater plants here. She paints a shape with a solid tone of watercolor, then before the paint is completely dry, she touches it with water on the tip of her pointed brush. She repeated this throughout the shape to get a pattern of light-colored flares.

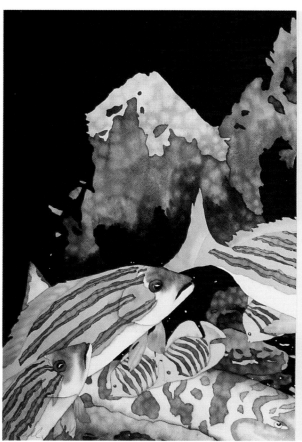
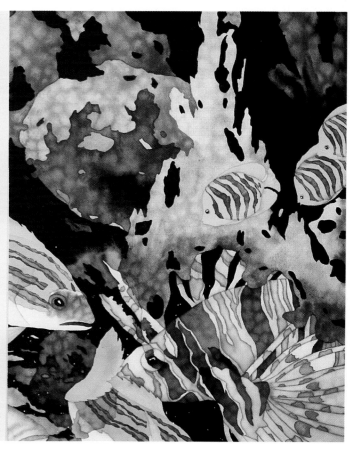

Washington Park Wood Duck
Kendahl Jan Jubb
Watercolor, 22″ × 25″

Working with birds and animals, Jubb divides the figure into shapes of the patterns that comprise it. Here there are the texture of the head feathers, the texture of the breast and the texture of the long feathers on the wings. The flat black negative shapes help unify the composition.

Trillium
Kendahl Jan Jubb
Watercolor, 16″ × 19″

A shape repeated over and over again in a composition begins to lose its meaning and become part of the abstract pattern. That happens here with the small, brown ducks. Notice how the black background gives depth to the negative space in this composition.

Chapter Eight
Putting Tonal Values to Work

Few artists can look at a blank canvas and see the image they want to create. Most of us have to put something on paper or canvas before we can begin to plan a final image. This is where you can really put tonal values to work for you.

When you plan a painting, you can provide a powerful structure for the whole painting by thoughtfully designing the value shapes. Where will the lights, medium values and darks go? Do you want strong contrast or a more muted feeling? Will the final image be predominately low key or high key? These questions will be answered by what you want the final mood of the painting to be.

For the beginner, the idea of planning may seem like a waste of time. "I'll work it out as I go along," you may think. "I'll lose the spontaneity if I plan it all out first." And a few artists are quite successful without ever doing any planning.

However, for most of us, any time spent in pre-planning the composition of tonal values, as well as the colors, figure gestures, etc., not only saves time, but also leads to a more powerful, deliberate painting.

Painters call these planning efforts "studies." There are many types of studies. Though one of the most valuable kinds is a tonal value study, there are also some other ways to help you plan a more successful painting.

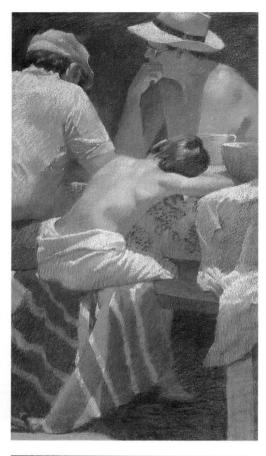

Played Out
Sally Strand
Pastel, 38½" × 21"

In Strand's sketchbook she tried out two different compositions for the painting *Played Out*. She divides her value studies into three tones—light, medium and dark, and those become the structure for her painting.

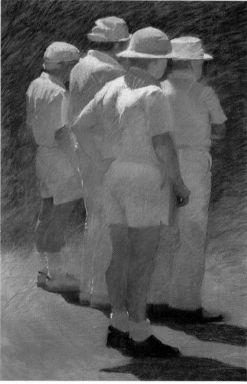

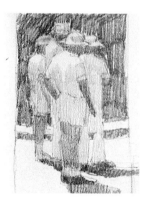

Men in White
Sally Strand
Pastel, 38" × 24"

Sally Strand's primary concern is the fall of light on her subjects. So when she sketches a scene, she pays most attention to how the light and shadows fall. You can see how closely the values translate from the small pencil study in her sketchbook to the finished painting.

Types of Studies

Studies can be for many different purposes and take any form, from photographs to elaborate paintings. More and more artists are relying on photographic reference material for studies to work out the subject and composition of a painting. This reference material could be a single black-and-white or color photo, or a series of photos, or even a photo collage.

Photos are an excellent way to record details and changeable conditions of weather and light. However, photos can flatten and distort shapes, alter color and change value relationships. Most artists recommend using several photographs or combining the use of photos with drawings and painted studies or both. Many artists prefer to have a live model or setup to refer to as they work, even when working from a photo study.

Drawings can serve various purposes and range from quick gestural sketches to intricate value renderings. You can use quick, loose gesture drawings to show the pose and placement of a figure, and thumbnail studies of major value shapes are an excellent way to study the value structure of a scene. More elaborate drawings give you an opportunity to explore lighting, form and composition.

Studies that show color values can also be quite helpful in working out relationships. Stephen Scott Young often does watercolor studies that are larger than the final painting. Sometimes the study, which is generally a spontaneous watercolor, is a more exciting painting than the formal piece.

Boxwood
Eleanore Berman
Oil, 36″ × 72″

Eleanore Berman's simple garden paintings are powerful because of the solid forms she creates. She gets those three-dimensional shapes by finding the lights and darks in an image and then pushing the contrast beyond what exists in nature. She explores the values first in small black-and-white studies. Then she develops the subject in a series of paintings. In the black-and-white photo of *Boxwood* you can see how she exaggerates the values to create dramatic, solid forms.

Sketchbook Studies

Studies can be done either for your own personal exploration or for public viewing, but in all studies there is a sense that the study is not as precious as the finished painting. The study is an exploration. It might work and it might not and if not, you will just try another way.

Sketchbooks are a great format for studies. To be most effective, a sketchbook should be small enough to be easily carried. There is a freedom about working in a sketchbook; probably no one but you is ever going to see it. You can record anything in the book — gestures, value studies, notes about light and colors — and know that this reference information will always be available to you.

Which Medium to Use?

For use in sketchbooks it is best to choose media that are simple and easy to carry around—pencil, ink, watercolors. For more elaborate studies you can use any medium. Many artists complete a small oil sketch to work out colors and values before starting on a formal oil painting. If you have concerns about executing a painting in a particular medium, try a smaller composition in that medium first.

Solving Problems

Since studies are intended for working out problems before you get to the finished painting, you should determine what problems you want to explore before you begin a study. In some, you will be designing the value structure. In others, it will be gesture or lighting. Many artists complete numerous studies before they begin a painting so they can work out many different concerns.

Remember, studies are a tool to make your life easier. There is not a right way and a wrong way to do studies. Whatever preliminary photos, drawings and paintings you do to prepare for a painting are useful as long as they help you explore the concerns you have for the future painting.

When someone is attracted to a painting from across a room, it is most often the pattern of light and dark—the tonal value structure—that he or she is attracted to. Other elements are usually appreciated later. So put all you've learned about tonal values to work for you. Take the time to do studies and to plan the underlying tonal values of your painting. The extra time you spend up front will be saved later when you skip those usual hours or days of frustration trying to correct a painting you're not happy with.

Nanny and Ezra in the Kitchen
Scott Prior
Oil, 80″ × 66″

Photo studies

Scott Prior paints familiar domestic scenes, but he waits until he catches them in dramatic or unexpected lighting conditions. He shot these photos as reference material for a painting with strong backlighting.

Pencil study

With pencil he draws a value study to put the figures together and work out the composition of value shapes.

Finished painting

After he has completed his studies and feels totally familiar with the subject and the composition, Prior begins the painting. He refers to his reference material and the original setting and figures as he paints.

Planning Value Patterns

"All my work is done in my sketchbook," says Mark Mehaffey. "By the time I get to the watercolor paper, I have already worked out the painting. If it doesn't work in the sketchbook, it doesn't matter how gloriously I handle color—it's not going to work."

The first thing Mehaffey looks for is a pattern of interlocking shapes. He studies the value pattern and asks himself if he can set up an interesting, light-dark-light-dark pattern throughout the painting. In his value sketches, he works toward a value structure that will give him a strong painting.

If the subject is an architectural scene, he begins with photographic studies, then works from those into his sketchbook. Whether working from photos or a live scene right in front of him, he looks for a focal point or center of interest created by strong value contrast to use as a starting point. He works out from that point, taking care that the value pattern does not become too repetitive and monotonous.

Often he has to rearrange the value shapes from the actual scene. He may do three or four different value sketches with different arrangements and then pick the one that works best. Sometimes just for fun he will reverse the values, keeping the shapes the same, but painting the lights dark and the darks light.

He says, "I keep the sketchbook open on the drafting table as I'm painting, but early on I begin to keep my eye more on the painting. Somewhere about halfway through, the painting takes on a life of its own."

Mehaffey believes that a lot of people are concerned with making a rock a rock or a tree a tree rather than establishing value relationships between the rock and tree and sky and ground. For Mehaffey each object or shape is important only for how it fits into the total pattern of the painting.

Summer Afternoon
Mark Mehaffey
Watercolor, 22" × 30"

Step 1

Mehaffey begins the actual painting with a full-sized contour drawing on tracing paper. He transfers the image onto a sheet of frisket film that he then attaches to watercolor paper.

Step 2

He cuts out and removes the covering film from the darkest areas of the painting.

Step 3

Then he sprays a beginning layer of value onto those shapes with watercolor and a mouth atomizer.

Step 4

Mehaffey repeats the process of cutting and spraying until the whole painting is covered with varying layers of fine dots of watercolor. The three photos on this page show the gradual buildup of values. The darkest values are, of course, those with the most layers of paint. He may use as many as twenty-five layers to create one dark value.

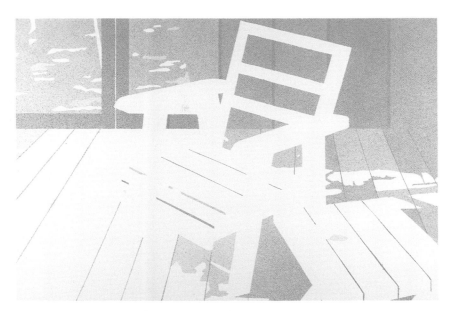

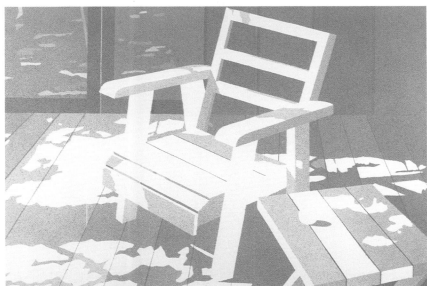

Plant Forms
Mark Mehaffey
Watercolor, 20" × 29"

Value study

This small pencil value sketch, only 3" × 4", shows how Mehaffey works out the forms and values of a composition before he begins his painting process.

Step 1

The beginning step is a full-scale drawing on tracing vellum. He then transfers the drawing to a sheet of frisket film and applies that to the watercolor paper.

Step 2

He cuts the darkest shapes out of the frisket film and sprays those with their first layer of watercolor from a mouth atomizer.

Step 3

He removes more of the film and sprays another layer of color, darkening the deepest values and laying in the middle tones.

Step 4

He continues removing bits of the film and spraying until he has built up the desired values throughout the composition. The finished painting reflects the value structure that he established in his early value studies.

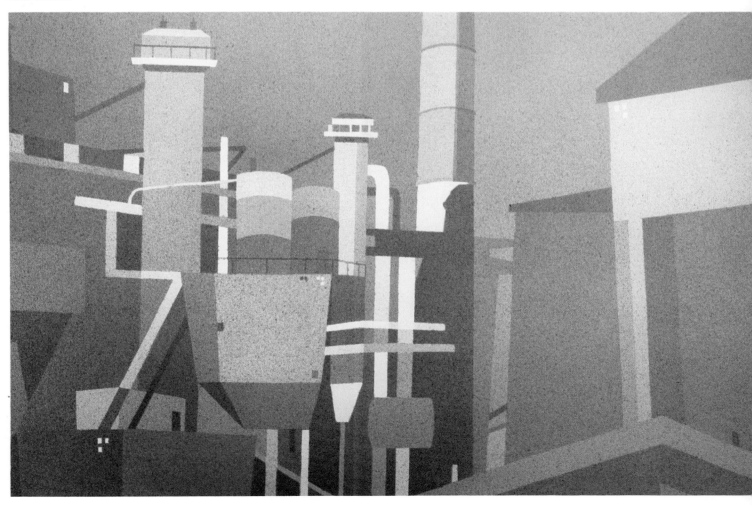

Dark Against Light

When Stephen Scott Young thinks of value in a painting, he thinks of extreme darks contrasted with extreme lights. He picks subjects in which the contrast is paramount, often black-skinned figures against sun-drenched fences and buildings.

He lives in Florida and travels to the Bahamas for subject matter. He explains, "The light in the Bahamas is such an intense light, it's almost an electric shock to see it. The challenge is trying to keep that feeling."

At times the contrast is so strong that he has to tone it down to make the painting work. Sometimes the colors, too, need toning down in that light—greens in that natural setting can look garish. He will adjust any values or colors to create the overall effect he intends.

He says, "Paintings are paintings; they're not what I see in front of me. It's impossible to recreate nature. That frees me to paint paintings and not try to paint what is really there. If you try to make it look too realistic, you kill it off."

What is ironic is that even with his attitude of not trying to recreate nature, Young's paintings are so powerfully realistic that people find it difficult to believe that they are watercolors.

He starts with value. He sees value before line and uses the division of value shapes as the basis of his compositions. He says he learned to paint light and dark by copying Rembrandt in watercolor.

White Umbrella
Stephen Scott Young
Watercolor, 21" × 30"

Thumbnail sketches

Young begins with thumbnail sketches in his sketchbook to develop the composition.

First watercolor study

He often does full-size watercolor studies before attempting the finished painting. Sometimes, he says, the studies are better than the painting because they are looser and fresher looking.

Second watercolor study

Here he changed the size of the figure's hand and arm and the angle of the fence. By the end of this study he had also decided that the red umbrella was too overpowering for the rest of the composition.

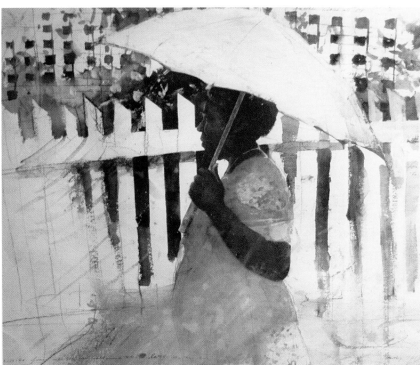

Third watercolor study

He made the umbrella white and added the latticework in the background. Now he is ready to begin the final painting.

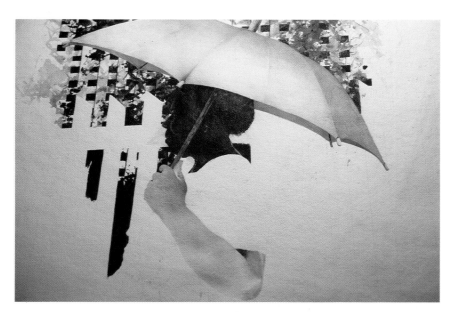

Step 1

Young begins by establishing the dark values of the face and the upper background. He uses mostly transparent watercolors, but with fifteen to twenty glazes, even transparent paint begins to look opaque. He lightly washes in the shape of the arm and hand and extends the dark values of the background.

Step 2

He darkens the arm and adds the underpainting for the dress.

Step 3

In the finished painting you can see the powerful contrast of light against dark that he began to lay out in the first thumbnail study.

Red Ribbon
Stephen Scott Young
Watercolor, 23½" × 23½"

The dark-skinned girl in this painting stands out powerfully from the light and light-to-medium values that fill the rest of the composition. Young creates a mood of isolation for the figure with the extreme contrast.

Castaway
Stephen Scott Young
Watercolor, 15" × 22"

Young shows how the negative space in a figure painting can be as vital a part of the composition as the figure. He makes the background interesting by placing light against dark shapes and textured against smooth shapes.

Conclusion

The secret to being a great artist is not in knowing, but in seeing. You can know all the theories and philosophies and techniques of all the greatest artists in history, but if you cannot see in front of you, your expression as an artist is severely limited.

Keep looking at the world around you. Look for the light and shadows. Look for the relationships between lights, medium values and darks. Let yourself fall in love with light; be in constant wonder at how light and shadow give drama to everything they touch.

Yes, learn to put down a flowing wash. Learn to scumble and glaze. Learn to mix a rainbow of colors. But always be aware that the foundation of every painting you do is the design of value shapes within it. When you have mastered value, you will be well along the road to mastering painting.

Permissions

Index

Improve your skills, learn a new technique, with these additional books from North Light